MW00862359

STORE #2675

ATE:_____

PROVAL:_____

There are tears in the nature of things.

VIRGIL

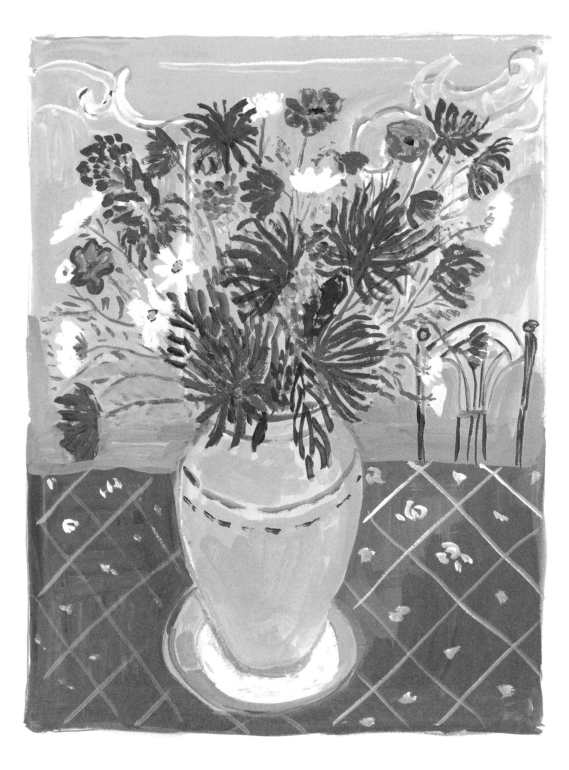

Still Life with Remorse

Family Stories

Maira Kalman

HARPER
INFLUENCE

An Imprint of HarperCollins*Publishers*

REMORSE

DEEP REGRET

implying shame
implying guilt
implying sorrow

In still lifes and interiors,

there must be a certain amount of remorse

lurking among the bowls of fruit,

vases of flowers and objects

scattered about the room.

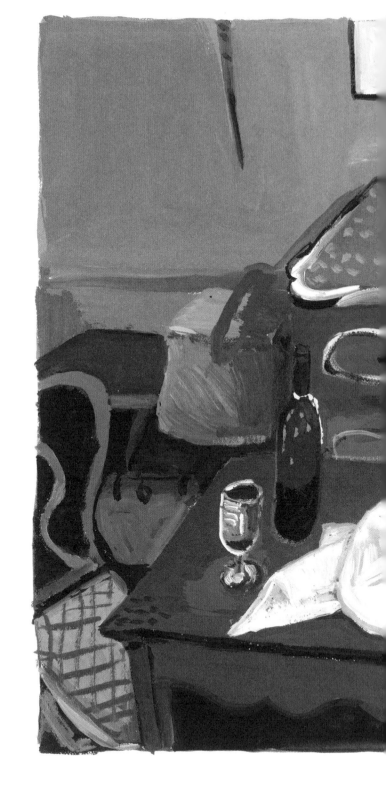

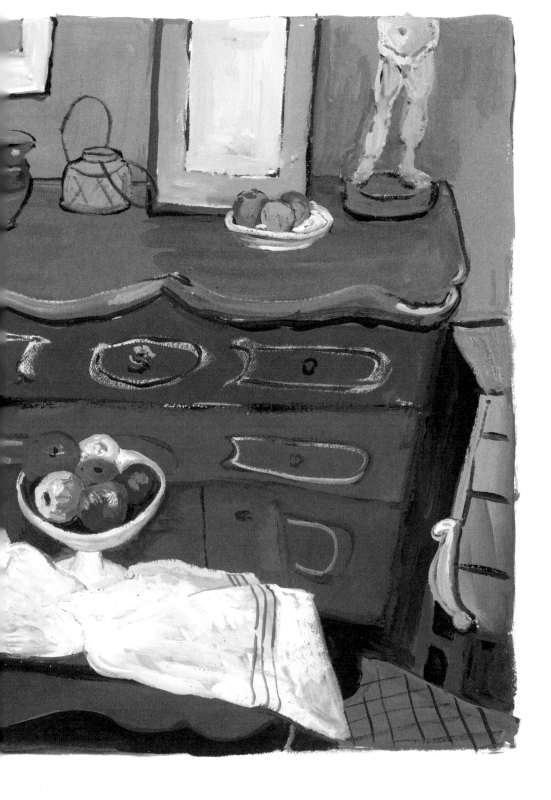

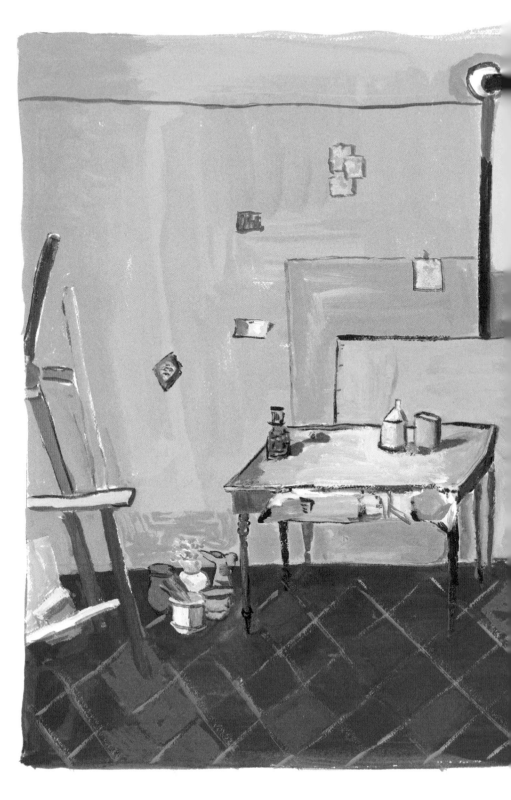

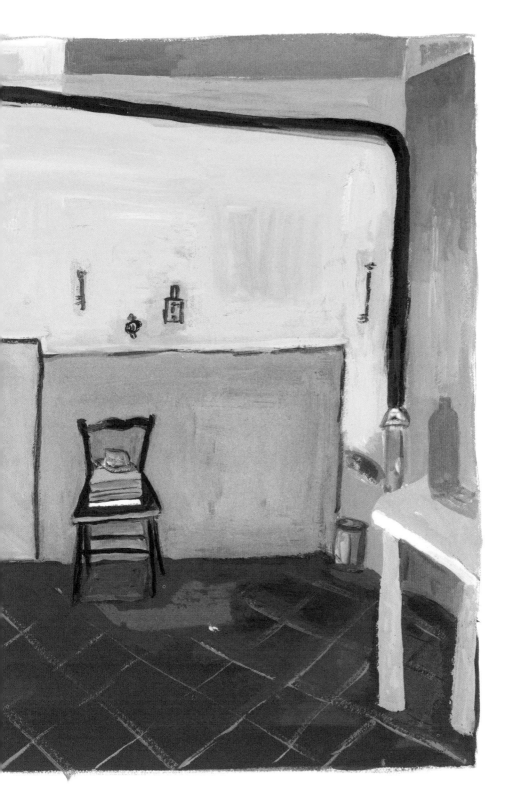

Happy families.

Unhappy families.

All the same, right?

 Ach. Ach. Ach.

 To begin,

 you are born.

To a long line of ancestors

 who are long gone,

but still yell or whisper in your ear

in the depths of night.

 A game of telephone

 played from one generation to the next.

 Garbled and confused.

 Glimmers of light.

 Misunderstandings.

 Errors.

And now, here you are.

 With the ones you love.

 Or the ones you don't.

The ones you cannot live without.

 The ones you would like to smite.

 Those who have disappointed you or betrayed you.

Those who have been kinder than you deserve.

And the kind ones who inevitably die.

And leave you feeling very much alone.

They are what you have.

 And if you think,

 at any given point,

 that you know what is going on,

 you are sorely mistaken.

And yet.

LEO AND SOPHIA

Sophia Behrs married Count Leo Tolstoy.
They were madly in love at the beginning,
had thirteen children in the middle,
and detested each other at the very end.

Only eight children survived to adulthood.
 Their favorite died as a little boy.
 That alone could do you in.

Sophia transcribed all of Leo's writings.
 Daunting.

They were wealthy

and surrounded by servants and family,

including Leo's sister, who was a nun.

Or dressed like a nun.

Sophia kept diaries and photographed the family.

Here, Leo having breakfast.

Here, Leo working in bed.

Here, Leo at the family table

with his omnipresent sister.

In the end,

Leo ran away from Sophia

and died in a train station.

In a bed, but still, not home.

And not with Sophia.

Does suffering include remorse?
I cannot speak for the Tolstoys.

When trying to understand
why human beings
do what they do,
a fog descends.

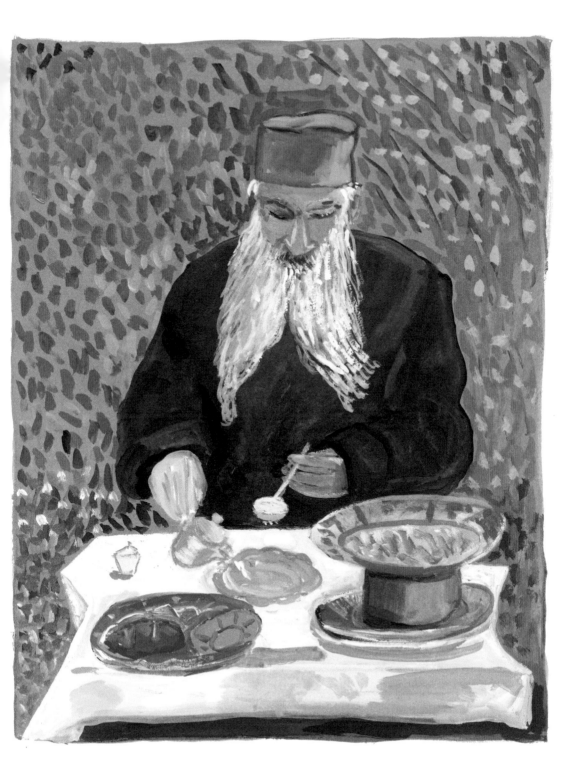

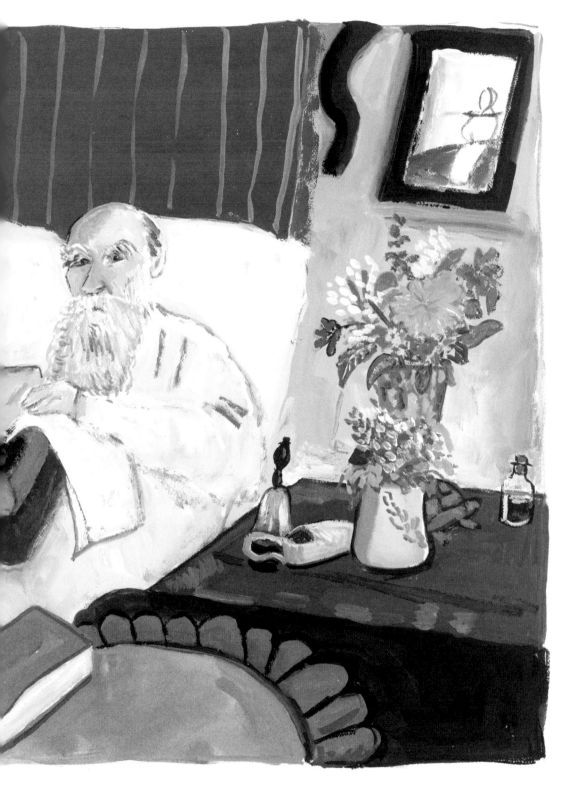

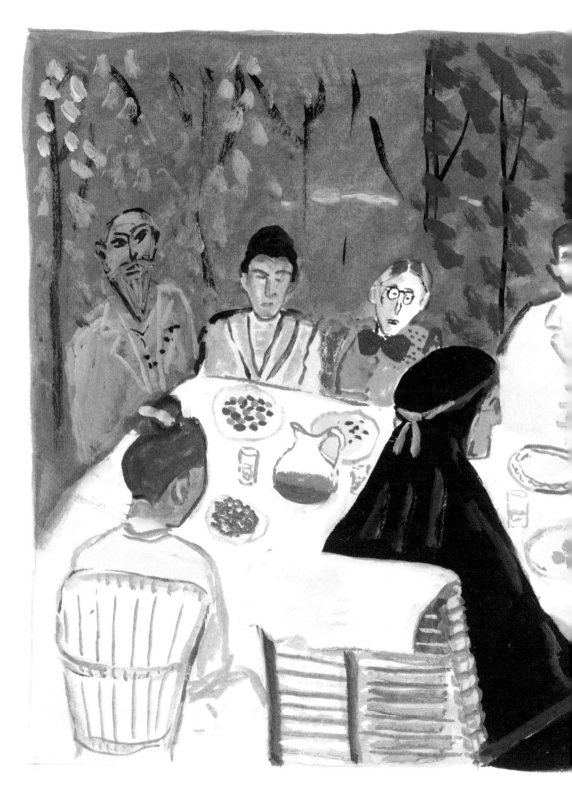

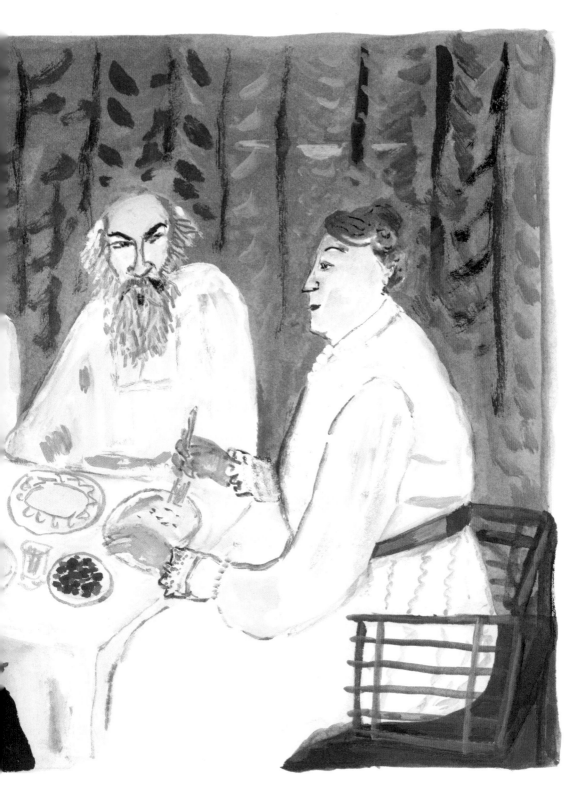

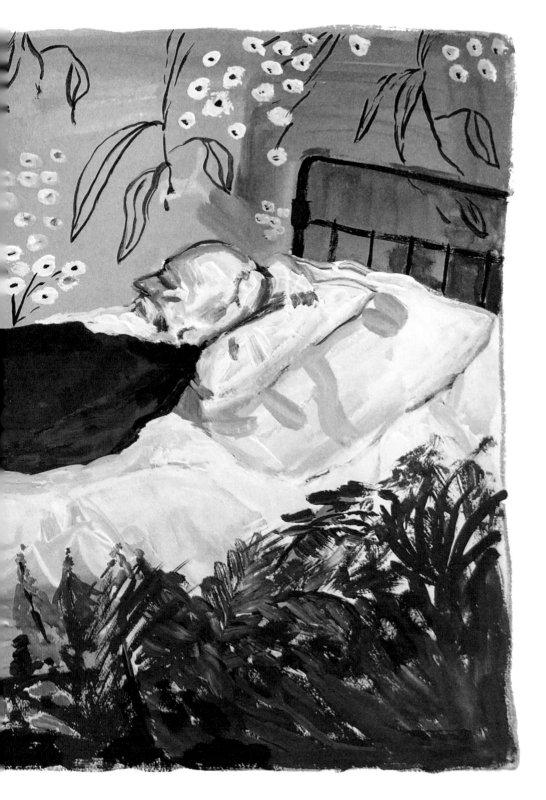

TZVI

My mother's father, Tzvi, was one of four brothers
born in Belarus. He was sweet and pious and
honest to the core. He wanted nothing more than
to pray all day and eat potatoes with chicken for
lunch. Followed by a nap. Followed by cake and
tea. Two brothers were reasonably honest. But
the eldest was devious. Maybe even a swindler.
Though it pains me to say.

They all worked for the eldest, building buildings
in Tel Aviv in the 1930s. He became very rich
and tricked his brothers out of money due them.

The swindler's daughter, who was very rich, grew
up to be very stingy and greedy. If the price of
half a roast chicken went up by a few cents, she
was outraged. She ranted and railed. Her face
turning purple.

Her daughters, who were also very rich,
grew up to be very stingy and greedy as well.
So they fought over money and never spoke again.

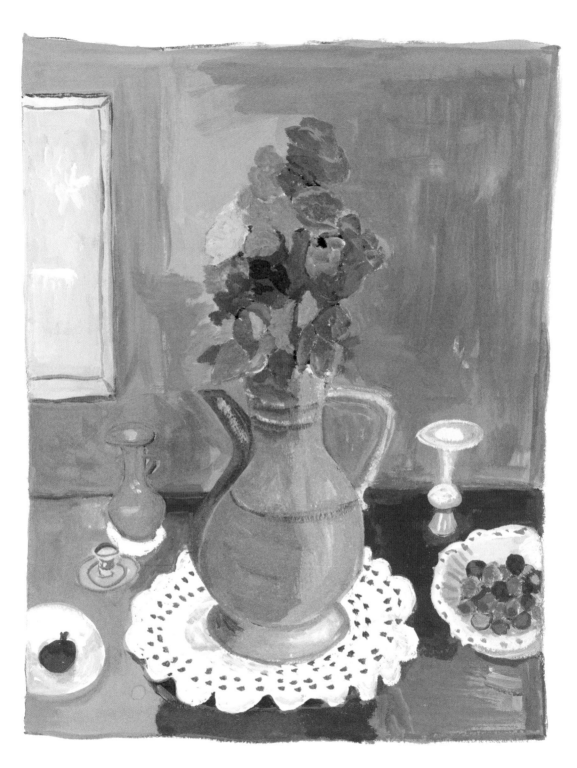

BELARUS

In my mother's village in Belarus,
the schoolteacher was anti-Semitic.
It seems strange because I thought
everyone was Jewish in their village.
But that was not the case at all.

If the children misbehaved, they had to kneel
in the corner and stay there for a very long time.
My aunt Shoshana was always misbehaving.
Always kneeling in the corner. She was unruly.

When the family said they were going to Palestine,
the teacher said, "Go to the rubbish Palestine!"
My grandmother cried for two days.

My grandfather, who went to Palestine
ahead of the family, ate an entire watermelon
and got typhus.

PESACH

My father Pesach, his older brother, and his younger
brother, left their little village in Belarus and came
to Palestine in 1939. Their parents stayed behind,
running their dry goods store, thinking nothing
bad could possibly happen. Of course they were all
murdered in the Holocaust.

My father joined an underground group fighting the
British for the independence of Palestine. He had a
job as a milkman. That was his cover.
He delivered bottles of milk.

I always thought there were bombs in the bottles.
But of course it was just milk.
I really don't know what he actually did.
But something.

After Israel became a state, my father became a diamond dealer.

He wore fancy suits and traveled deluxe.

His friends were rich diamond dealers around the world.

Their wives so well dressed.

Bouffant hairdos.

Jewelry.

The older brother started a construction company

and one day, as a result of a freak accident on some machinery,

had to have his foot amputated.

After the older brother's foot was amputated, he became bitter
and disheveled. Unkempt and coarse. His wife was famous for
serving unbearably dry chicken and rice.

My father and his brother were not the best of friends.

I don't know what the problem was.

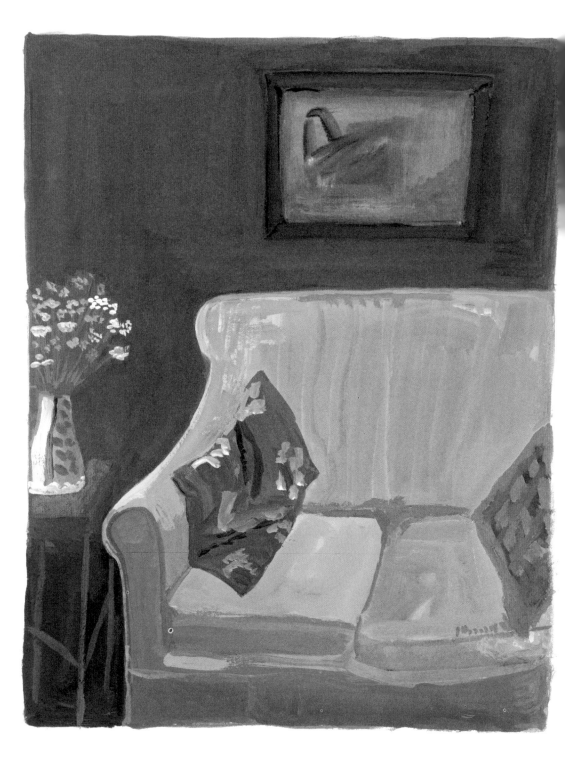

The younger brother,

gentle and kind, had troubles.

I don't know what they were.

But they got worse and he was despondent.

One evening he went out to the field

with his gun

and shot himself.

Tormented and then dead.

By that time we were living in the Bronx.

My father got the telegram that his brother

was dead. He walked wildly up and down

the living room holding the telegram in his hand,

wearing only underwear and sobbing.

I don't remember anyone

going to comfort him.

Not at all.

MOSHELEH DIES IN PALESTINE

Mosheleh was the son of Fanny.

He was killed in the War of Independence.

He was only seventeen.

He was killed by the British.

His mother could not cry.

Everyone said to her,

"Cry Fanny, the worst has happened to you. Cry!"

But she couldn't cry.

The entire city followed the funeral for Mosheleh.

His body was in a jeep.

Fanny spoke to her dead son.

"Maybe you will get up."

She was heartbroken,

never having said a good word to him

when he was alive.

MRS. PEARLMAN'S SON

Mrs. Pearlman's son also died in that war.
The Pearlmans lived next door to my
grandparents on the second floor.
On the ground floor lived Lombroso the
shoemaker and his wife.
They had a little son.

One day my aunt and uncle took Lombroso's son
to the beach. He promptly got lost. They ran up
and down the beach in a panic looking for him.
The fear was that he had gone into the water
and drowned.

 Finally they found him.
 He had not drowned.
 But he could have drowned.

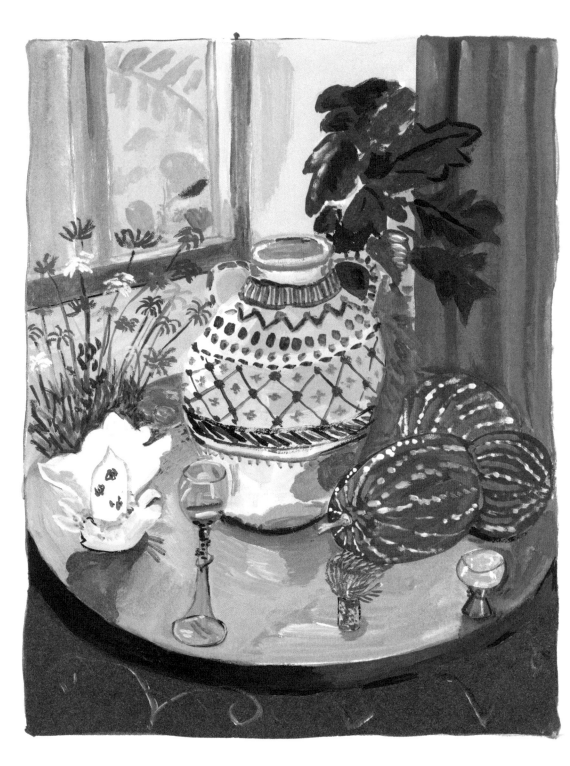

UNCLE

Once our uncle
sat in a gigantic black inner tube
and floated in the sea.

He fell asleep and drifted
farther and farther from the shore.

He was a tiny dot in the sea.
People went out in a boat to rescue him.

He could have been swept out to sea.
But he was not.
But he could have.

This is what we call the *possible-probable* remorse tense.
Suffering after the fact over a disaster that could possibly
have happened but did not. This tense occurs very
frequently in our household. Daily. Even hourly.

KIKA

My sister Kika was born a blue baby.
It was 1945 and she had pneumonia.

Penicillin had just been invented by Jonas Salk,[1]
who later married Françoise Gilot, who had been
the lover of Picasso for ten years and had two
children with him, Paloma and Claude.

At any rate, the way that Picasso and Françoise
met was this. He was at a café in Paris with
his then lover, Dora Maar. He saw Françoise
and ambled over to her with a bowl of cherries,
inviting her to come to his studio.
You know what that means.
 And so it went.

[1] As some of you may know, it was ALEXANDER FLEMING, not JONAS SALK,
who invented penicillin. Jonas Salk, of course, invented the polio vaccine.

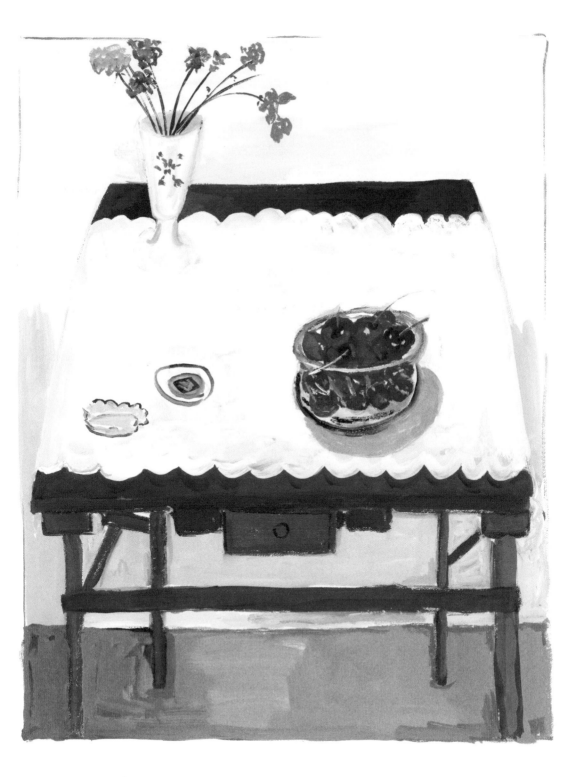

But back to my sister.

The family doctor, Doctor Machnitzky, said
they must not give her the injection.
It was too new and too dangerous.
But another doctor, Doctor Rabinovitch, said
they must give her the penicillin
or she would surely die.

Machnitzky and Rabinovitch stood in the
hospital corridor and argued vehemently,
their arms waving like furious, broken windmills.
Finally, Rabinovitch prevailed,
and the penicillin was given,
and her life was saved.

At first she was as ugly as a frog.
But she grew up to be a beautiful girl.
 However, she had asthma, and in those days,
 that was a big problem. She could not breathe.
 The doctors said the conditions in Tel Aviv
 were not healthy for her.

So at the age of four, she was sent to live

in a home in Jerusalem with religious people.

Kind of like a Hasidic-Dickensian orphanage.

It is hard to understand how that could happen.

This little innocent child was sent

to live away from her family.

How could she be expected not to be despondent?

How could she be expected to overcome the sorrow

of being sent away from the family?

They believed it was

for her well-being.

But no no no.

What remorse

we feel to this day.

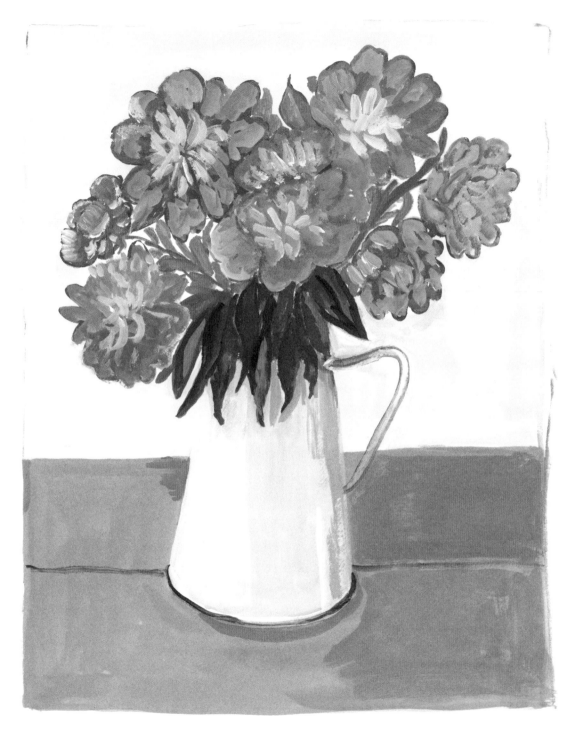

SARA AND MAIRA

When I was born, my mother became gravely ill.
 For three months she lay in the hospital
 hovering between life and death,
 delirious with raging fevers,
 unaware of my existence.
My father, who loved grand gestures,
made sure there were always flowers by her bed.

 I went to live with my grandparents.
 How could my father be expected
 to take care of a newborn baby?
 My aunt Shoshana and her family
 were also living with my grandparents.
 So my aunt also took care of me.

 I slept in a baby carriage
 and was parked for much of the day
 in the kitchen as they cooked
 the endless meals for the family.

Every Friday many cakes were baked.
I must have been lying there
smelling all of those smells.
 They entered into me
 instead of my mother's milk.

 Of course they took me out for strolls
 in the fresh air next to the sea.

They must have pushed my carriage
up and down the promenade,
worrying and walking.
 Walking and worried sick.

Little by little my mother recovered.
She came home and life began.

 She always walked very quickly,
 and I was always lagging behind her.

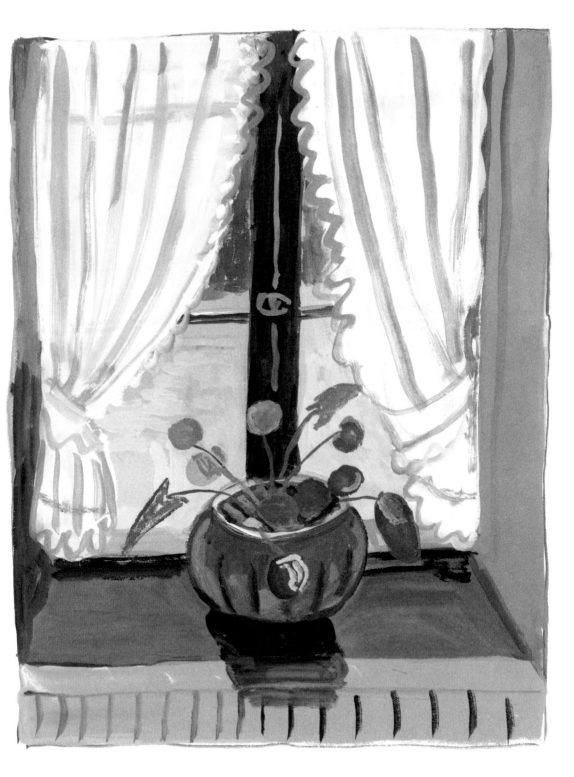

NOW IS NOT ENOUGH.
I WANT THE PAST

The other day I called Franz Liszt.

"Franz, what's happening?"

"Not too much," Franz replied casually.

"We are going to dinner at the Schumanns'.

I am sure they would love you to join.

Give them a call."

"Is Mendelssohn coming too?" I asked.

"No. He is in one of his moods."

So I called Robert and Clara. Clara picked
up, which made me happy because she is much
friendlier and more gemutlichkeit than Robert.
Robert makes me nervous. I never know what
to say to him. Because he has frightening mood
swings. Does he hate me? Does he like me?

I don't have a clue.

Unnerving.

I asked if I could join for dinner.

"Of course. We are cooking a goose
with lingonberries. And Salzburger Nockerl
for dessert. Come on over."

I went over and it was so much fun.
The linens were snowy white.
The velvet drapes were green.
The crystal shimmered.
The candles glowed.
The food warming and filling.
We played music.

There was a little bit of dancing and some other diversions.
Pipes smoked. The eight children played and had a merry
time. Once in a while Robert looked distressed. Distracted.
I knew why. Because Brahms showed up with a basket
of fancy fruits, moving like a magnet to Clara.

Clara said comforting things to everyone and moved around
so elegantly in her silk dress. That Clara. She is incredible.
I went home aglow with friendship and bonhomie.

Robert ended his life

in a mental institution

at the age of forty-six.

Such a sorrowful thing.

Ach.

The suffering.

But Clara went on.

Tirelessly performing.

Taking care of the family.

She was unstoppable.

In our family we say,

if Clara could go on,

anyone could go on.

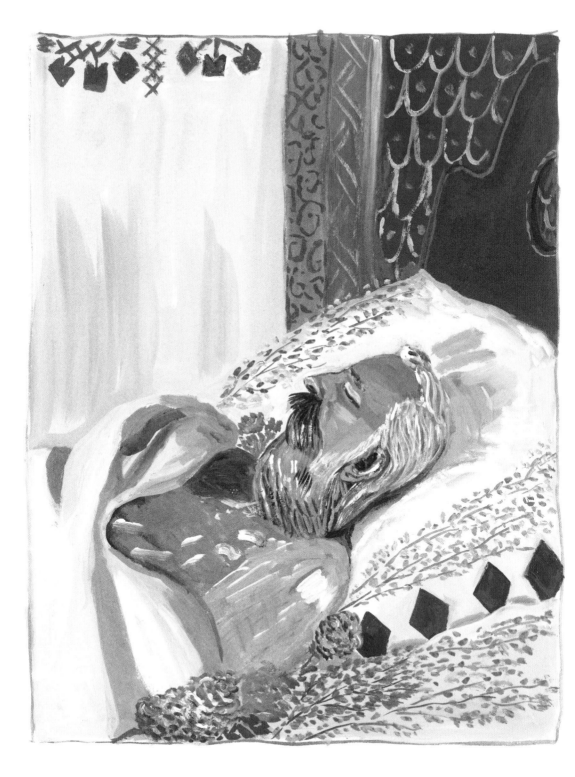

AND WHAT OF BRAHMS?

Did Brahms spend his life composing music
 (like the Intermezzo 117 Opus 1)
for his beloved Clara?
Did he compose everything for her?
 Some say, undoubtedly, yes.

He remained Clara's loyal helpmate
until she died. Her chevalier, so to speak.

A chevalier can be a man or a woman.
How heartwarming to have a kind soul to turn to
for help with all decisions and problems.

And when it was his turn to die,
he lay on a beautiful bed
covered in flowers.

 Rest in peace, dear chevalier.

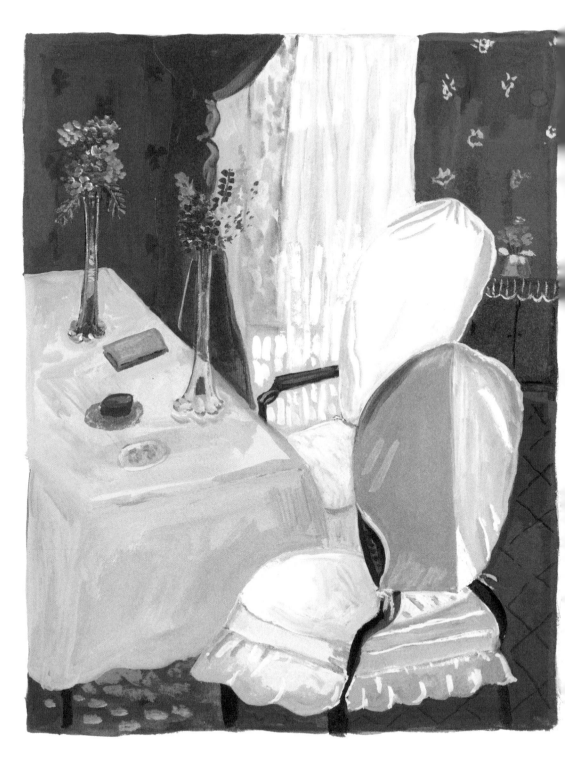

KAFKA AND MAHLER

Kafka was bilious. And queasy.

Mahler too.

 Bilious and queasy.

 And it goes without saying,

 nauseous.

 Breakfast. Lunch. Dinner.

 Bilious. Queasy. Nauseous.

 Each would put his hand on his stomach

 and grimace and then groan.

 What the rooms witnessed and endured.

 In our family it is the same.

 Heavy meals. So much food.

 Grimace and groan.

 Grimace. Groan. Time. Death.

Mahler wrote music to these lyrics

 DARK IS LIFE.

 SPRING IS HERE.

 THE BIRDS ARE SINGING.

KAFKA'S FAMILY

One day Kafka sits down to write.
 He has been feeling bilious,
 but now, thank goodness,
 he is feeling better.

His father and mother are bickering in the kitchen.
The father is interfering in the running of the household.
He is unbearably overbearing.
 "Why don't you make the potatoes this way,
 not that way? Why don't you make this meat,
 not that meat?"

 Kafka cannot take it.
 How is he supposed to think, let alone write?
 The clattering dishes and the killing voices.
 The father that squelches and squashes him
 at every turn.

 On the other hand, Kafka might
 have been utterly insufferable.
 Like who?
 Like everyone.

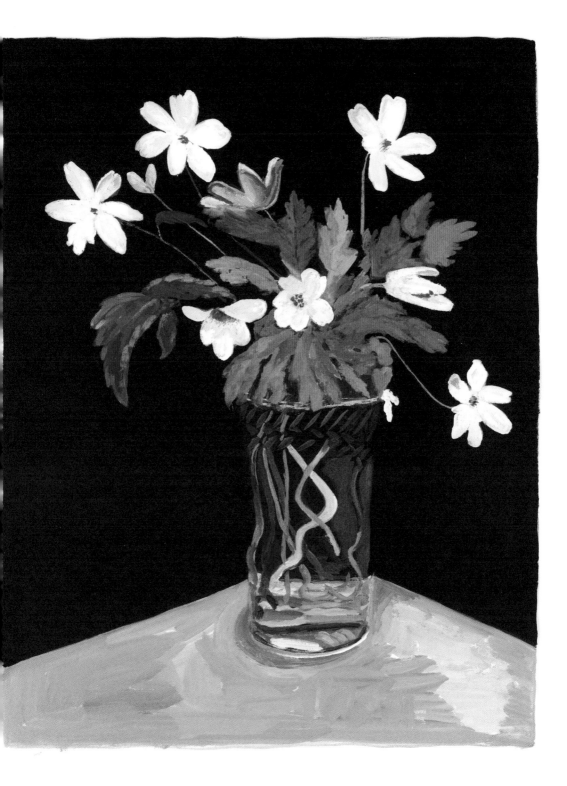

DELACROIX

Here is my painting
of a painting by Delacroix.

 I cannot claim
 that I was Delacroix in a past life.
 But I can't rule it out.

 Delacroix was friends with Chopin.
 And was one of his pallbearers.
 I can imagine doing that.

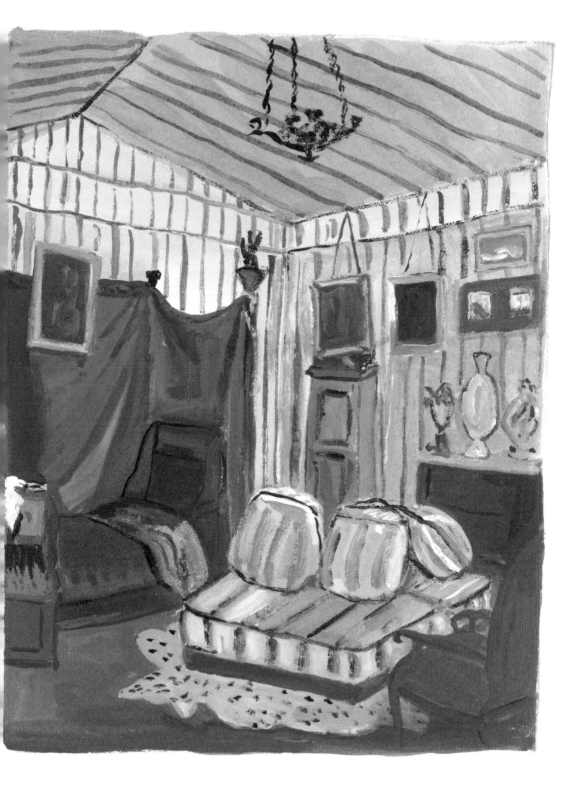

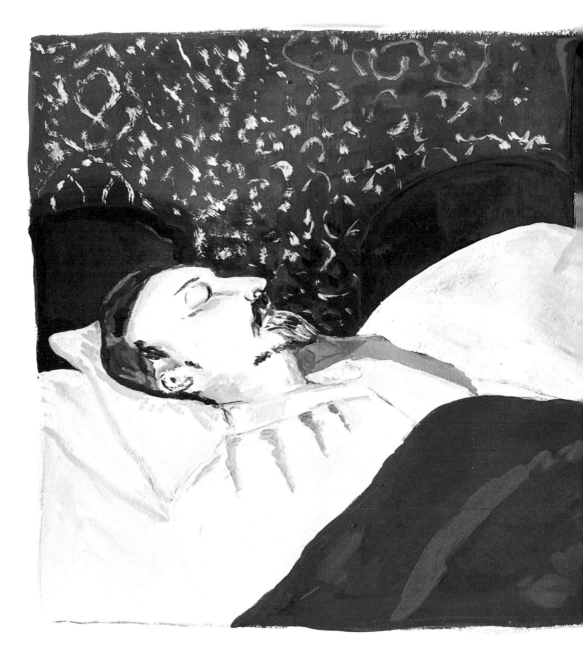

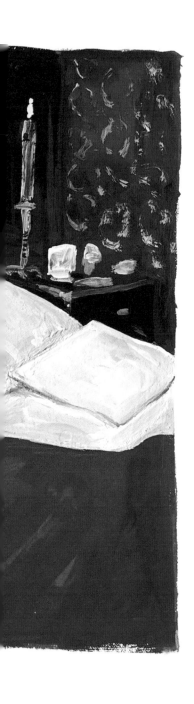

CHEKHOV

Chekhov had a famously unhappy marriage.
A groan escapes your lips. He, of all people,
should have been cherished. Surrounded by
loving children. Showered with love.

Instead, he died of tuberculosis at the age
of forty-four with his wife, Olga Knipper,
by his side. Or not by his side.[1]

But wait. Why am I blaming Olga Knipper?
Why is she the culprit? Chekhov was a ladies'
man and maybe even a bounder. He broke
many hearts. Olga Knipper was a woman
trying to start a career as an actress.

Long after his death, we love Chekhov.
Some consolation, but not for him.

[1] Accounts differ.

Right about now,
you might be
thinking,

 wouldn't it
 be nice
 to have a
 little
 musical
 interlude?

 Un po'

 di

 musica?

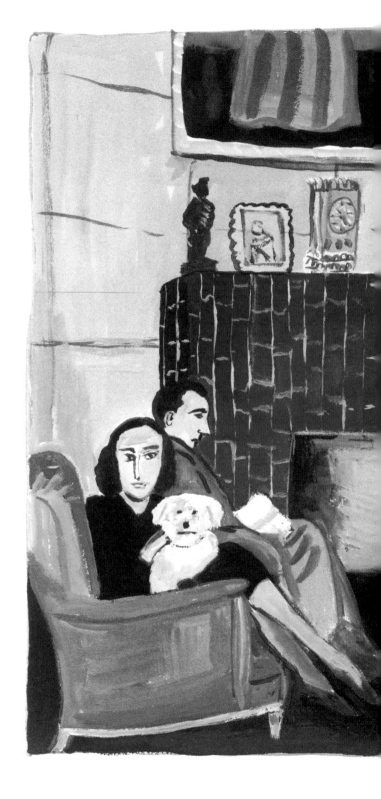

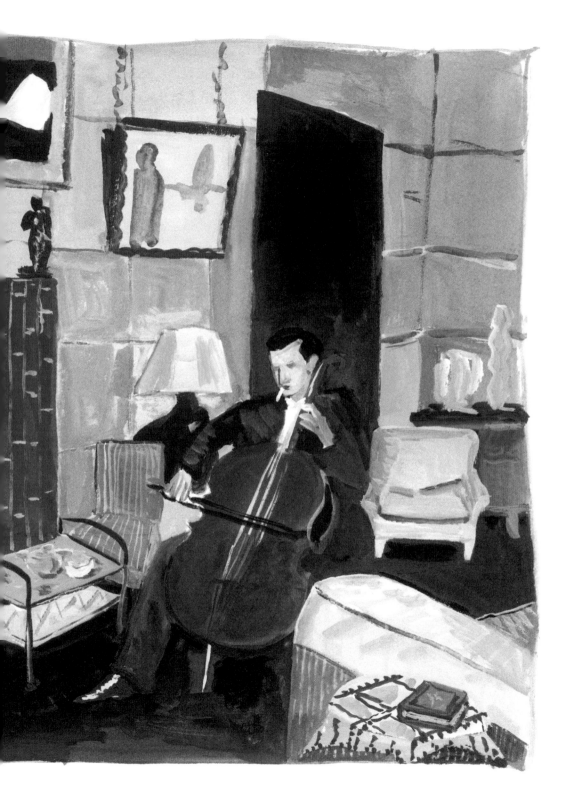

Ombra Mai Fu
from Serse 1738

George Frideric Handel

Ombra mai fu
di vegetabile,

cara ed amabile,

soave più

Frondi tenere e belle
del mio platano amato
per voi risplenda il fato
Tuoni, lampi e procelle
non v'oltraggino mai
La cara pace
Né giunge a profanarvi
austro rapace

Never was a shade
of any plant

dearer and more lovely

or more sweet.

Tender and beautiful fronds
of my beloved plane tree
Let fate smile upon you
may thunder, lightning and storms
Never disturb your
dear peace
nor may you by blowing winds
be profaned

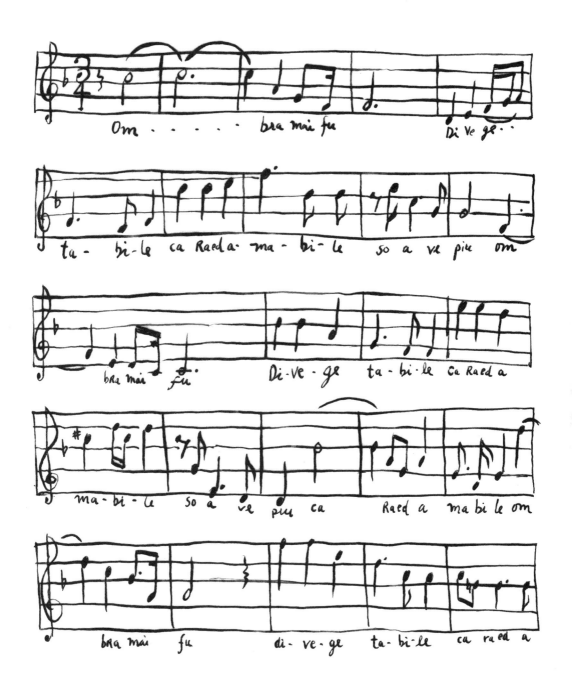

CLEOPATRA AND CICERO

Cicero couldn't stand Cleopatra.

It started like this.
He wanted to borrow a book from her library.
And Cleopatra said, "Sure," because she was pithy.

When it came time to loan him the book,
she conveniently forgot. "Where is my book?" he asked.
"Whatever," she answered. "Whatever?" he thought.
"I'll show her whatever." So he got even, and wrote
letters about her to Atticus. "I detest the queen. And
while we are at it, I can't stand Antony."

And then a bit of time passed, and Cicero
thought the contretemps was over. Not so fast.
Antony had Cicero's head and hands chopped off.
So he was killed, obviously.

So much for asking to borrow a book.
So much for history. And ruling.
And destroying everything.
Remorse? Not a mention anywhere.

note:
Mark Antony on the mantel.
Cleopatra chose the wallpaper.

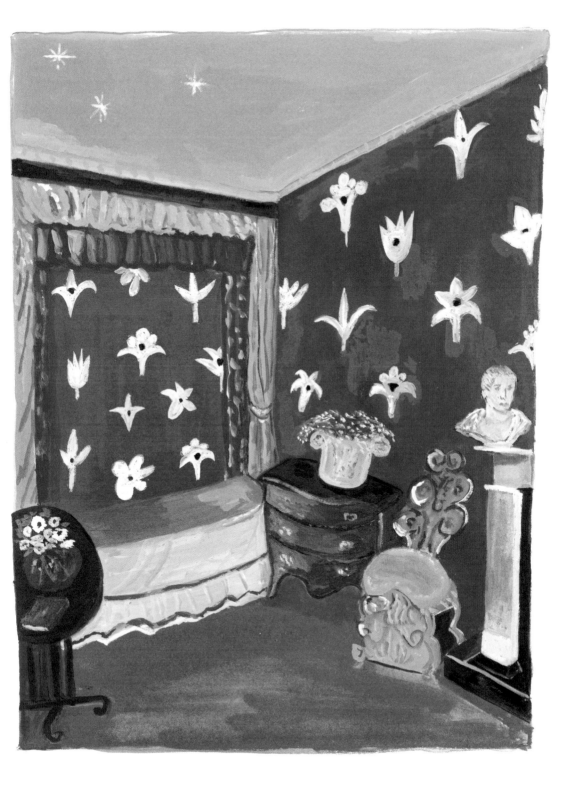

PESACH, AGAIN

My mother and father's relationship deteriorated

to such a point that my mother had a nervous breakdown.

She was incapable of doing anything.

So we came and took her away

while my father was at work.

We packed her suitcase while she stood there stunned.

 When my father came home, he realized,

 first slowly, and then with a bolt,

 that my mother was gone.

 He did not know how this could happen.

 We had not a second's hesitation.

 Not an iota of compassion for him.

 She had to escape and that was that.

And then, a few years later,

my father died.

But before he died,

he went slowly into dementia.

And was found wandering the street in his underpants.

And so, because my sister and I lived so far away

and were not on the best of terms with him

(*oh remorse, remorse*)

 it happened that we assigned a nephew

 to be my father's guardian.

 It turned out that my father had hidden money

 and diamonds in a bank in Switzerland.

 (*Oh greed. Ah Switzerland.*)

 The nephew managed to steal

 all of the diamonds and money.

 But in a freakish factory accident,

 his right hand got cut off.

My father died in a nursing home.
Gentle and toothless.

Perhaps he imagined

flowers by his bed.

And fresh fruit.

But delivered by who?

DARK IS LIFE.

SPRING IS HERE.

THE BIRDS ARE SINGING.

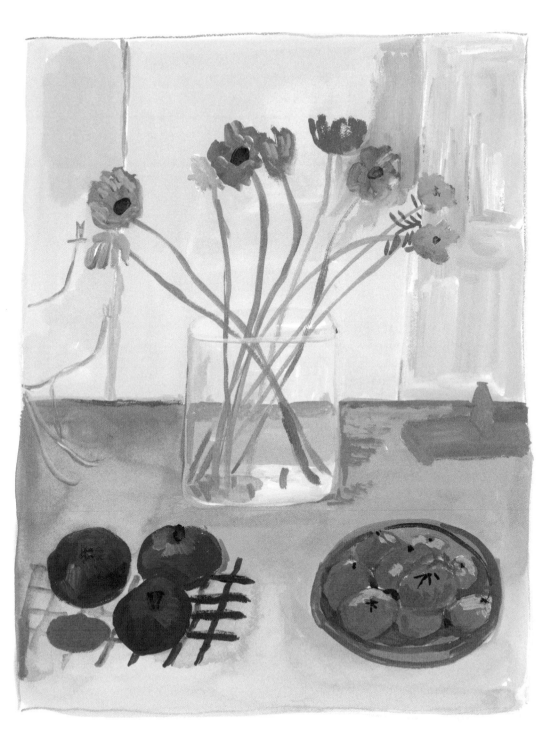

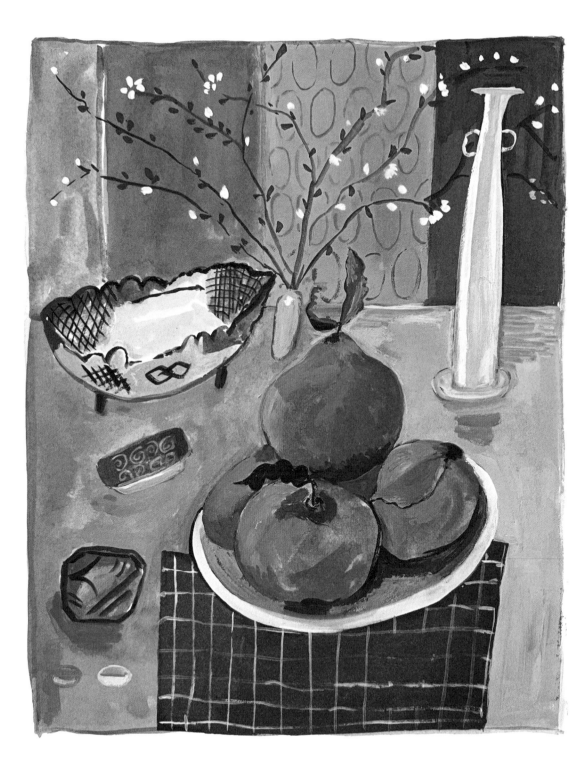

SHEETS

Once, a man and a woman were married.

She made excellent jams of all kinds, including quince.

　　And she was fastidious.

She loved to wash and iron the sheets all the time.

To her, it was important to dry them in the fresh air.

So she draped them all over the furniture to dry.

The man could not sit on the furniture

when the sheets were drying.

And it made him furious.

They fought about it.

　　　"Why do you have to dry the sheets all

　　　　over the furniture? I can't sit down!"

　　She completely ignored him.

　　She couldn't care less.

One day the woman had draped the sheets

over the furniture and the man was boiling

with fury. He yelled at her. To no avail.

　　And then he dropped dead.

　　So you could say the laundry killed him.

A CLUMP OF GRAPES

One of our aunts, Pishkeh, was very well read.

And pedantic. Pedantic Pishkeh. She felt the

rest of the family were a bunch of illiterate boors.

 Her eyes had a slightly malicious twinkle.

One day she invited my uncle and his family over for high

tea, in the British manner. She served little sandwiches,

petit fours, tea and a platter of grapes. My uncle sat

on the sofa, nonchalantly plucked a grape from the bunch

and popped it into his mouth. Pishkeh was aghast.

How could he not snip off a little stem of grapes with the little

scissors so obviously sitting next to the platter? What kind

of animal plucks a grape and plops it into his mouth without

stopping to snip and plate? She was furious and told him so.

He couldn't care less and told her so,

also implying she was crazy.

She wrote to the etiquette advice column of the newspaper,

venting her shock and dismay. She asked if such an action

could be forgiven. No one remembers the paper's response.

 We are left in the dark as to the proper behavior.

 In her defense, some things are unbearable. Many things.

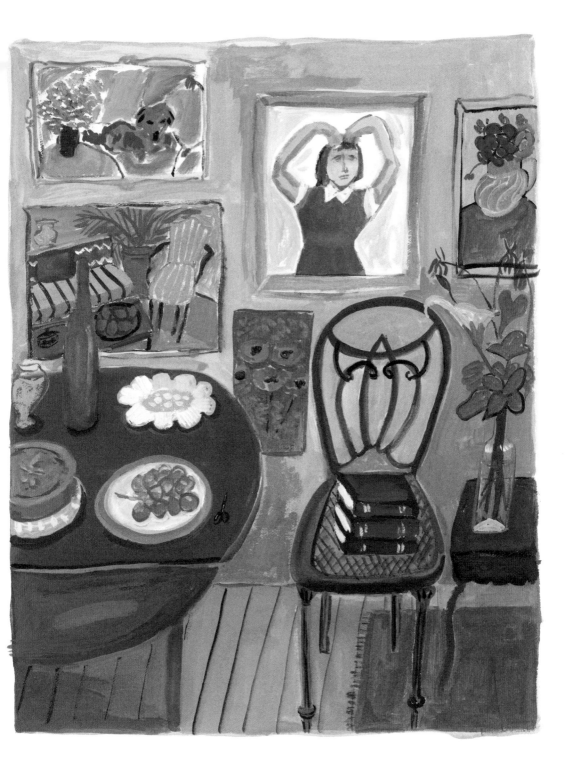

TABLECLOTH

There was a woman who was a very young woman, eighteen
to be exact, when she married a blond, blue-eyed man.

"Why the rush?" her father, who owned a bakery, asked.

So many reasons. But no answer.

The man was one of eight children (not the Schumann family,
but another), and his mother was a wonderful woman who was
lovely and kind to everybody. But my friend could not abide her
intrusion in her life.

"Maybe you want to use this tablecloth, not that tablecloth."
"Maybe you want to make an orange cake and not a lemon cake."
"Who asked you? Who asked you?" my friend kept saying in her head.
And maybe even out loud. "WHO ASKED YOU?"

There is no doubt that we are all filled with remorse
for all of the unnecessary advice we felt we had to give.
Why say anything? Why intrude on someone's life?

Well, the mother-in-law died of course, and the woman
left her husband, who had become abusive,
and married a man whose mother was dead.
End of problem. But only the beginning of remorse.

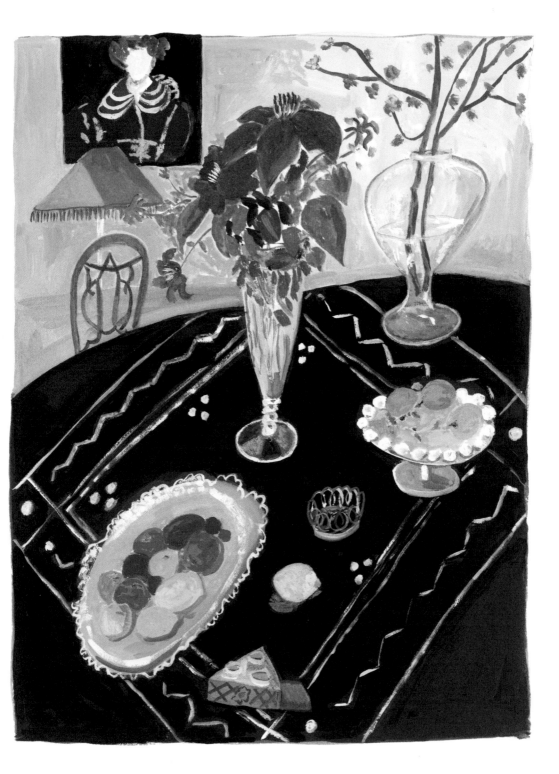

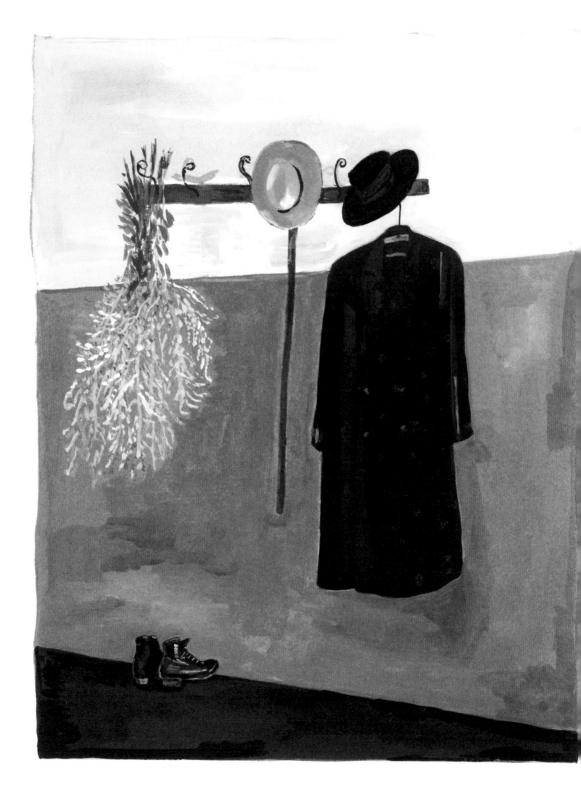

THE WINDOW

We had a relative who sold lumber.
He was very skinny and always wore
a heavy black coat which in Israel
was very strange.

He got involved with unsavory people.
Or he did something unethical.
 It is unclear.

At any rate, they were chasing him to make him
pay back money he owed them.
He ran up the stairs of his house,
and to escape, he jumped out the window.

He did not die, cushioned by his heavy black coat,
but he broke every bone in his body.
He then went to South America
and was never heard from again.

STUFFED PEPPERS
(GRIEF KEEP WITHIN)

My cousin made me stuffed peppers
because she knows how much
I love them.
And that is who she is.

　　She made four and hid them
　　in the back of the refrigerator,
　　wrapped in foil
　　with two rubber bands.
　　Signaling, STAY AWAY.

But her lodger came home and,
rummaging around the refrigerator,
found them and ate two.

When she came upon him eating, she said,
　　"But I made these for my cousin."
　　　"But I left two," he said, unabashedly.

GOULASH

A husband and wife were planning a dinner party.
They decided to make a delicious goulash.

"Don't forget the potatoes," the man said.
"I am not putting in potatoes," responded the woman.
"We are going to have wonderful polenta instead."

 "But everyone knows it is not an authentic
 goulash without fifty percent potatoes,"
 said the man.

At this point, unable to contain myself,
because I was sitting with them,
I yelled,

 "We don't want potatoes! We want polenta!"

Sometimes you just have to say what's on your
mind. And to hell with the consequences.

 At the dinner, no one held a grudge.
 Or so it seemed.

FRENCH POETS

This is a sticky wicket.

There are extraordinary artists
that are not at all easy to be around.
You want to know their work,
but not have them over for a babka and coffee.

The poet Gérard de Nerval (1808–1855)
took his life in a dank Parisian alleyway,
hanging himself from a post in the middle of the night.

When they found him,
he was still wearing his hat,
a melon bowler.

He was destitute. Drug addled. Dissipated.
Despondent. Deranged. Derelict.
Diseased. Dead. Done.

Who else can we think of that fits that description?

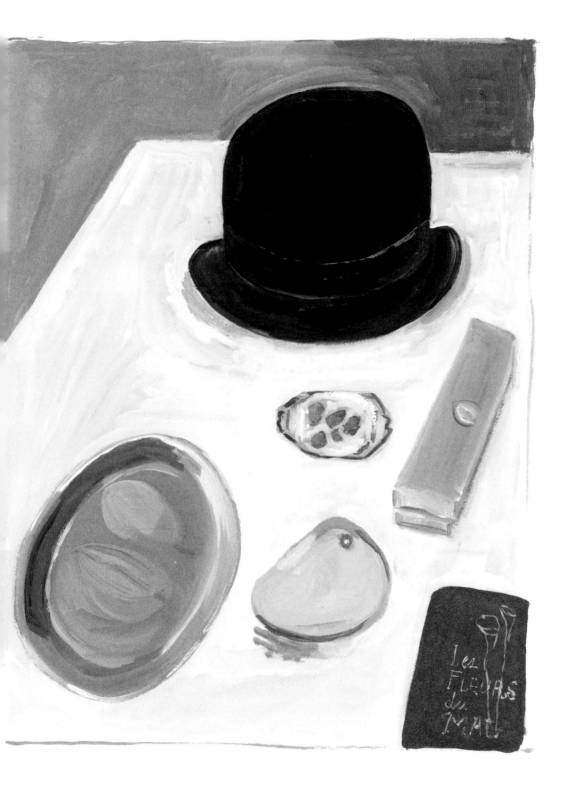

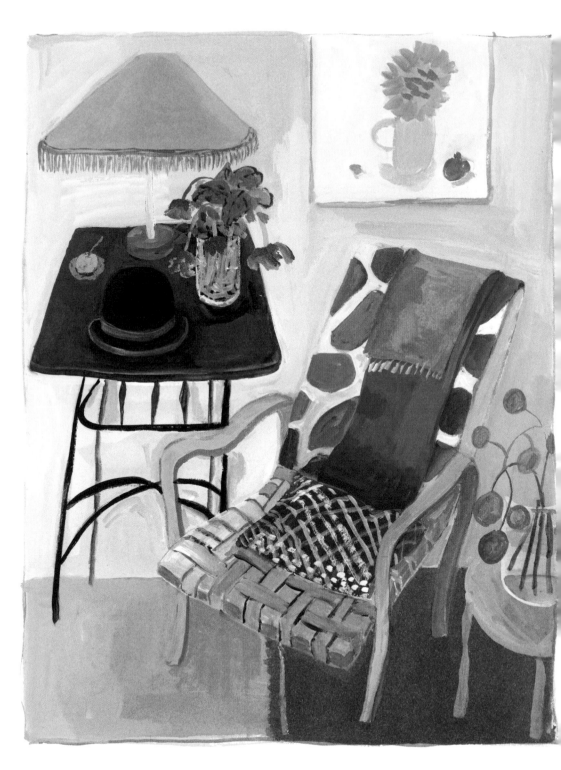

charles BAUDELAIRE (1821–1867)

arthur RIMBAUD (1854–1891)

paul VERLAINE (1844–1896)

Geniuses of literature
that ravage your soul.

They knew no constraints.
Spewing and scandalizing.
Living like madmen.

They expressed
the seething savagery
of our mundane lives.

"Time eats our lives."

C.B.

You know who was not crazy?

 MALLARMÉ.

He did not run around town like a madman.

 He knew how to pace himself.

 And still be a great artist.

Mallarmé outdid all the rest in the looks department.

It's good to have a thick shawl to warm you

on chilly French nights between 1842 and 1898.

 By the way,

 they all revered

 EDGAR ALLAN POE (1809–1849)

 By the way,

 if you are going to revere anybody,

 it should be MARCEL PROUST (1871–1922)

 But that is a much bigger subject.

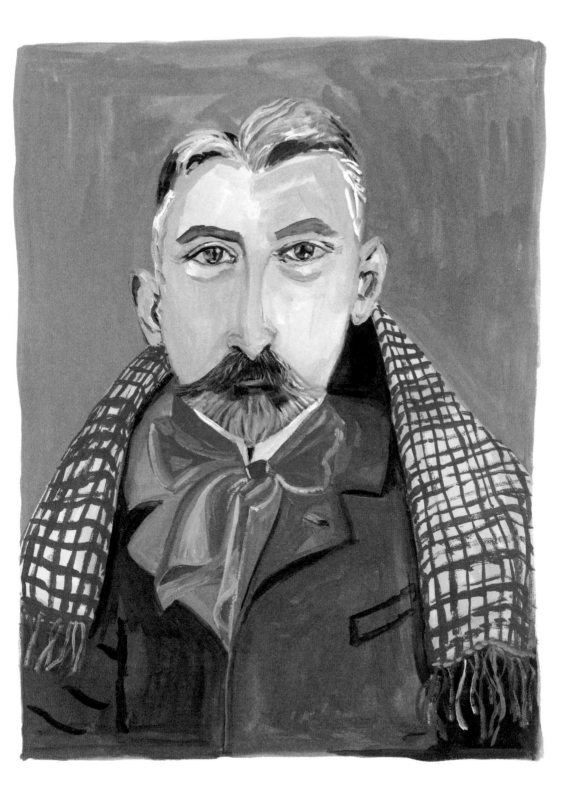

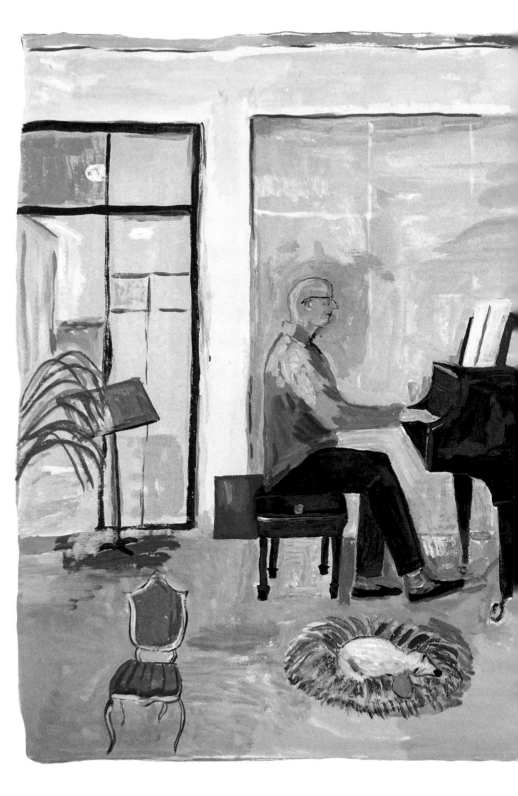

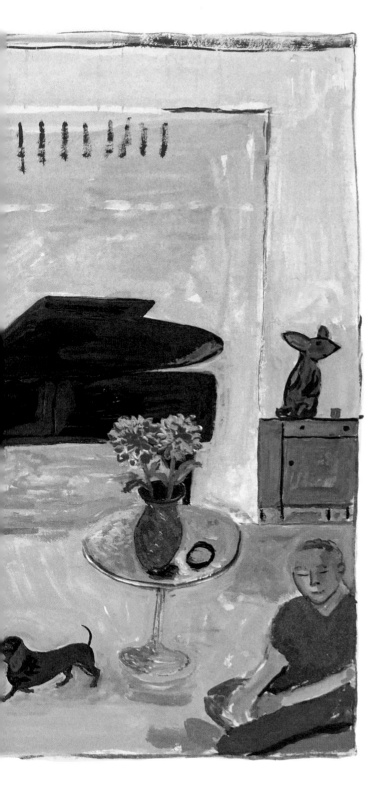

Could this be
a good time
for
another
musical
interlude?

*Ein weiteres
musikalisches
zwischenspiel?*

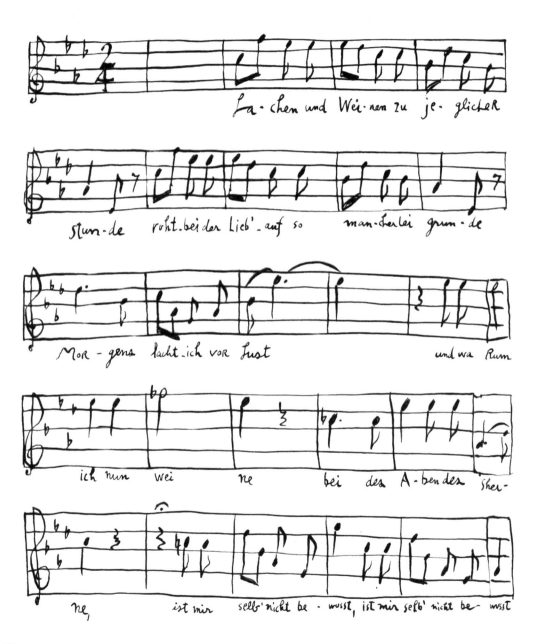

Lachen und Weinen
 Zu jeglicher Stunde
Ruht bei der Lieb auf so
 mancherlei Grunde
Morgens Lacht' ich vor Lust
Und varum ich nun weine
Bei des Abendes Scheine
Ist mir selb' nicht bewußt

Weinen und Lachen
 zu jeglicher Stunde
Ruht bei der Lieb' auf so
mancherlei Grunde
Abends weint' ich vor Schmerz
Und warum du erwachen
Kannst am morgen mit Lachen
Muß ich dich fragen,
 O Herz

Laughter and tears
 at any hour
Arise in Love from so
 many causes
In the morning I
 laughed with joy
And why I now weep
in the evening light
Is unknown even to me

Tears and laughter
 at any hour
Arise in love from so
many different causes
In the evening I wept with grief
And why you can wake
In the morning
 with Laughter
I must ask you
 Oh my heart

TSUNDOKU

I was limping down the street in Tel Aviv
and ran into my cousin.
She is a great swimmer and a great reader.
She swims during the day and reads at night.
And eats ice cream while reading.

She has piles of books, many unread.
There is a word for that in Japanese.
TSUNDOKU.
And it is not a criticism.
It is meant as a delight.

Beautiful stacks of books
that may never be read
but simply sit happily in your room
smiling at you.

My cousin's father was in love with my mother when
they were very young. He was adopted by my family
after his family had been murdered in the Holocaust.

He had four brothers
who had not come to Palestine.
In the little village of Lenin in Belarus,
the Nazis forced one brother to kill the other.

My cousin's father was very gentle and kind.
He had a crooked finger, which always fascinated me.
He came into the kitchen to talk to my aunt Shoshana.
She gave him a glass of seltzer and I looked at his finger.
 He always smiled.
 But also looked like he was on the verge of crying.
 His face was all crinkled up.
 My cousin said he was an angel.

> You can't decide to be an angel.
> It has to be in your essence.

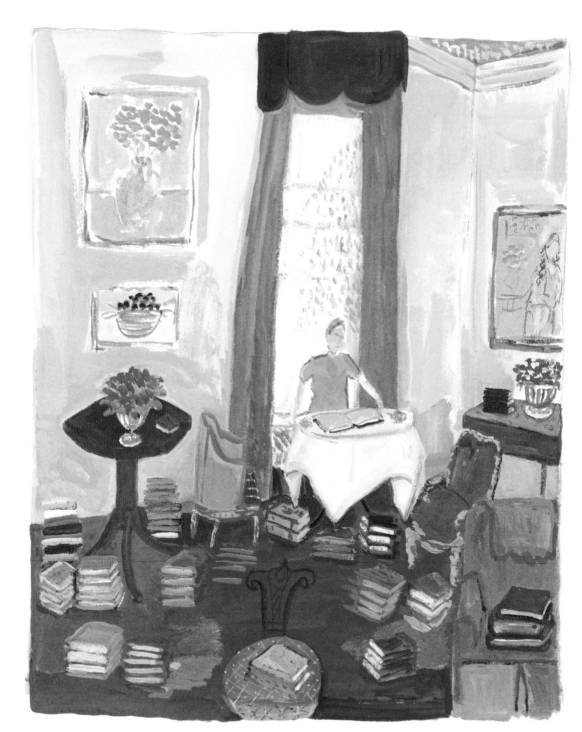

Back to our beloved books.

They ask for nothing.

They fill the room

with everything you need.

Salvation in their presence.

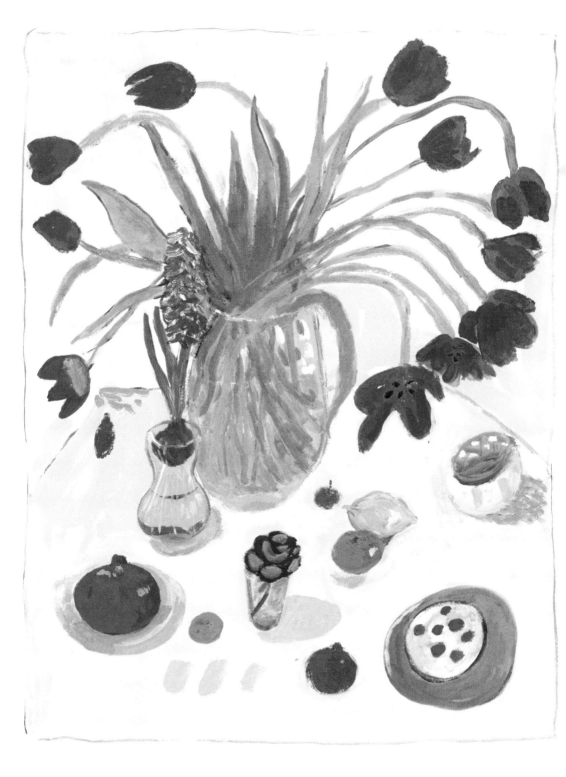

THE PLACE WAS A MESS

My 101-year-old aunt went to visit
her 93-year-old sister-in-law, Aliza.

If truth be told, no one liked Aliza.
Always bitter and complaining.
 Why my aunt walked up three flights
 of stairs to visit her is a mystery to me.
 But then, the obligations of family explain a lot.
 Not liking is hardly an excuse not to visit them.

 The place was a mess.
 Clothes and things piled everywhere.
 Nowhere to sit.
 So they sat on stools in the kitchen.

 The things that don't work out are often the most real.
 The mess rings true.

My cousin told me that Aliza had a son who she coddled
and carried around until he was fourteen. When he opened
a deli, she baked cakes for him to sell. Which sounds like a
nice thing to me. But I must add that my aunt told me he
never had a deli and Aliza never baked cakes for him to
sell. So now we are at a truth impasse.

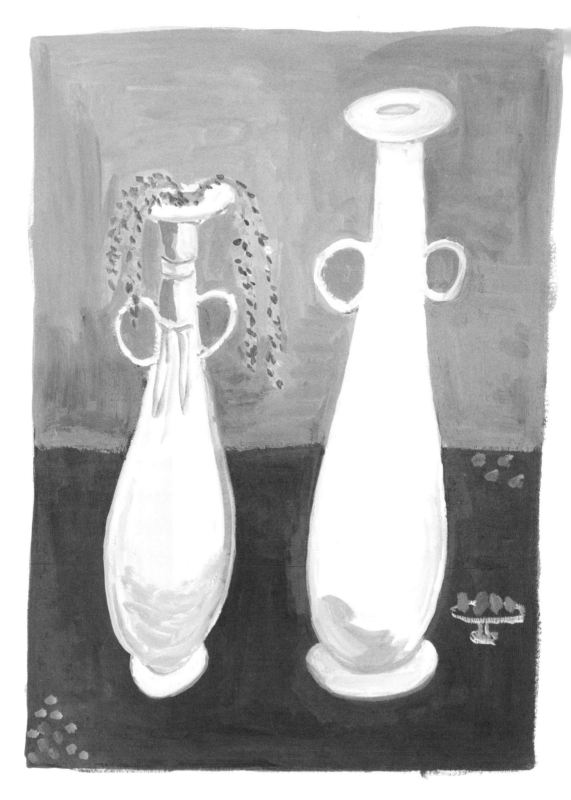

THE PETULANT

Ach. Those pharaohs.

So petty. So peevish. So petulant.

They wrote letters to one another on clay tablets.

One pharaoh wrote to another pharaoh,

> "You knew I had a cold. Would it have killed you
> to send me a get well card? Shame on you."

Another pharaoh wrote to a pharaoh,

> "I sent you a beautiful assortment of golden housewares.
> And you sent me some shabby gift made of wood and tin.
> Do you think I am an idiot and can't tell the difference?
> Shame on you."

I added the shame on you part.

But that was implied.

> If you get an annoying letter on a clay tablet,
> do you smash it and say, "The hell with that
> pharaoh?" Very possibly.

> So what have we learned from our ancient
> ancestors about living a kind, loving life?
> Nothing. Absolutely nothing.

WHAT COULD
POSSIBLY GO WRONG?

Czar Nicholas and Czarina Alexandra
had a perfectly nice afternoon
blithely oblivious to all the signs.

> They had a picnic of coulibiac.
> They sauntered through the woods
> amidst fluttering yellow butterflies
> and fragrant blossoms.

Vladimir Nabokov also walked through the
Russian woods collecting butterflies. Later, he
walked with his wife, Véra, as they searched for
butterflies the world over. But not in Russia.

At any rate, we return to the Czar and Czarina.

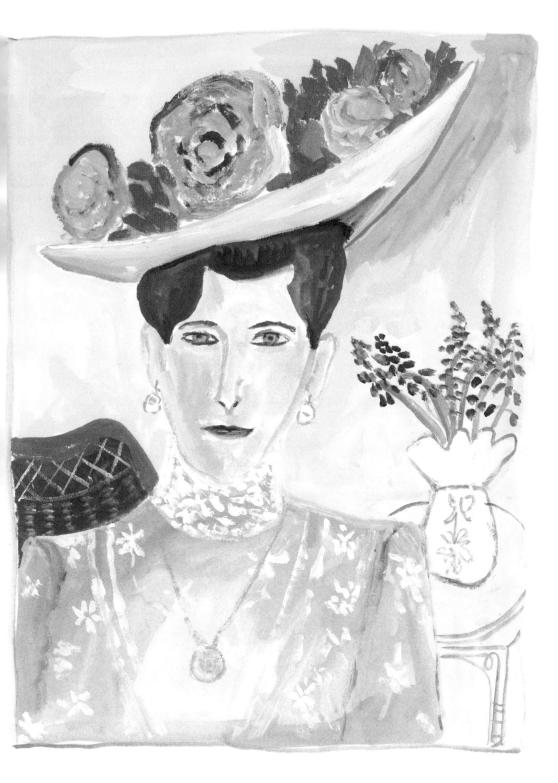

They strolled through the Hermitage
and inspected their immense art collections.

At their country estate they gave some orders to
random serfs. One of the serfs might have been
my great-grandfather who played the trumpet.

The serfs were living under misery
and more misery.

When my great-grandfather (or someone else)
got the signal, he arrested all of the Romanovs,
huddled them into a basement
and the next thing you know—
well you know what happened.

Then Lenin.
Then Stalin.

Then misery and more misery.

The Romanovs could have lived longer if they
had just been a teeny bit nicer to their people.

But they had not an iota of remorse
about anything.

Lenin and Stalin?
Same same.
Not an iota of remorse.

This is lack of remorse on an epic scale.

And still we have
breakfast, lunch and dinner.
And midnight snack.
And still we sing.

DINNER WITH
MY FATHER

Not far from a vase of flowers like these,

my father told me that his death

would be on my head.

nice.

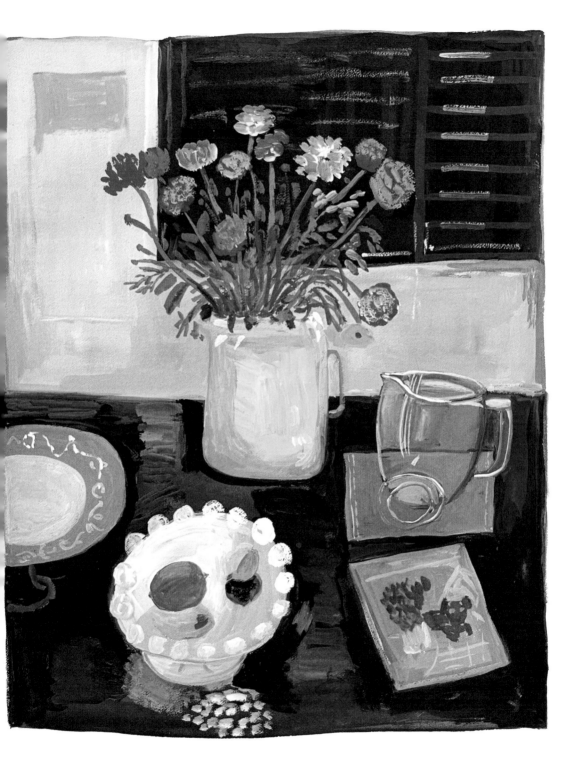

We had met at a restaurant in Tel Aviv.
I don't remember who called who,
or what the reason was for getting together.
Perhaps I wanted to calmly explain to him,
following the divorce with my mother,
how awful he had always been.
It did not go over well.

We quickly started to argue about furniture
and all of his and our history. But it was
incoherent, confused and insane.

When we left the restaurant
and he was walking to his car,
he turned to me and said what he said—
leveling a curse on my head.

He, who I am certain, had never heard of Lear.
I, for some inexplicable reason,
did not take it seriously.

Why should I?

He was wrong and I was right.

I just stood there

not having any idea what to say.

We walked away from each other

and that was that.

And then, not too many years later,

when he no longer knew who he was,

in the grip of dementia,

he was found wandering the street

in his underpants.

I have told you before,

but it bears repeating.

DARK IS LIFE.

DARK was Pesach Berman's life.

DREAM

I dreamt
someone else was stupid
for a change.

Such a relief,
albeit a fleeting one.

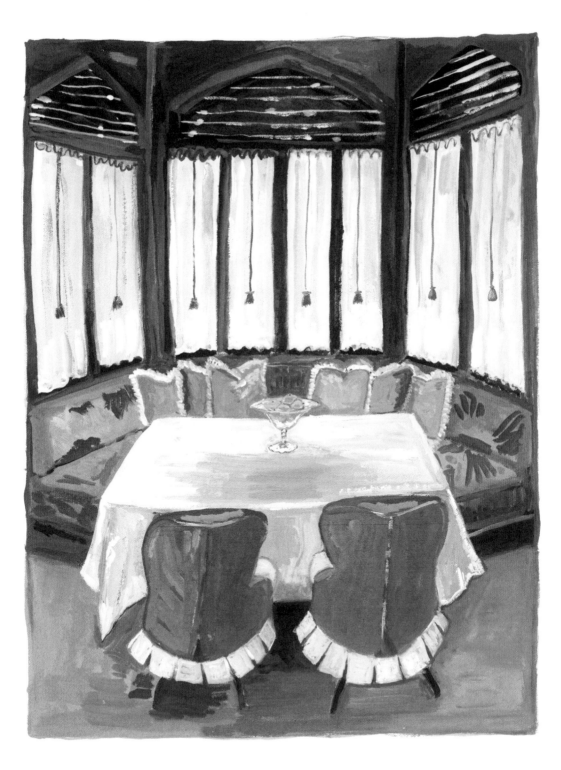

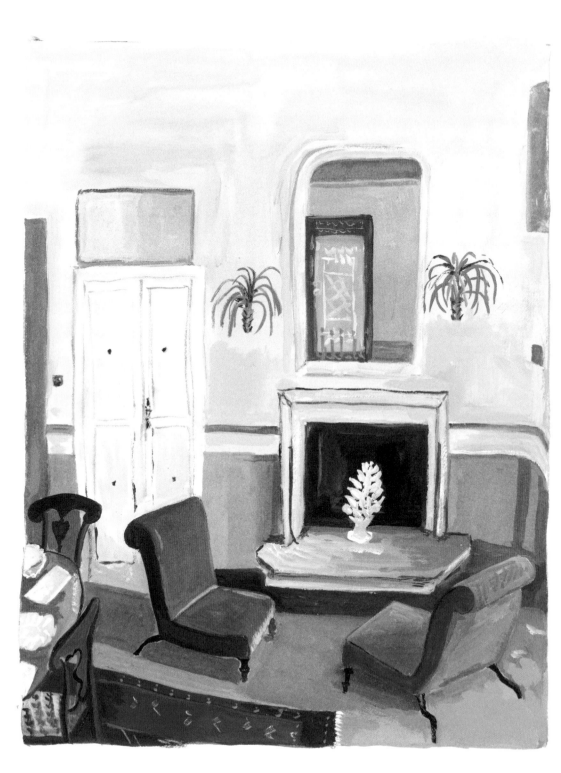

TIBOR

In a room not unlike this one,

I had a wretched fight with my husband.

The man I could not breathe without.

A frenzy of anger and disappointment.

Over what?

Over something and nothing.

And then he died.

Not right after that fight,

though that does happen.

But not so many years later.

I grieved and wept and was bereft.

And part of me is to this day.

And yet.

If he were still here,

or better yet,

if he returned from the dead,

would we be wiser and not fight?

Would our days flow

in the honey of love?

My father-in-law (who often wore an ascot and was
rather lordly) could never say my name correctly.

Maria

Mairiah

Marah

It just never came out right.

I knew I could not stand him.

The feeling was mutual.

But we soldiered on,

exchanging presents at Christmas.

Which reminds me, my husband's parents were Jewish.

But during the war they were able to get
Christian identity papers that saved their lives.

Thinking it prudent to maintain the deception when they
fled to the United States after the Hungarian Revolution,
they brought their three children up as Catholics.
Catholic School. Church. My future husband Tibor
toyed with the idea of becoming a priest.

When Tibor and I fell in love, my father said,

"Over my dead body will you be with a non-Jew"

(which did not faze me at all). So then, Tibor's mother

told him that in fact they were all completely Jewish.

For Tibor, that was good news.

For his father, George, it was a bad turn of events.

When I was with George, I felt mute and askew.

To escape, I would imagine myself elsewhere. In a great

house in England with massive flower arrangements

and interesting people hanging about discussing Proust.

It never occurred to me that a Jew would never be

welcome in those homes. Fantasy is fantasy.

George has been long gone. But Tibor's mother is still

very much alive. She told me that the only big remorse

she has is never revealing to the children that they are

Jewish. She is ashamed that they hid it from them.

She also has remorse for having a horrible sister.

But that is not at all the same thing.

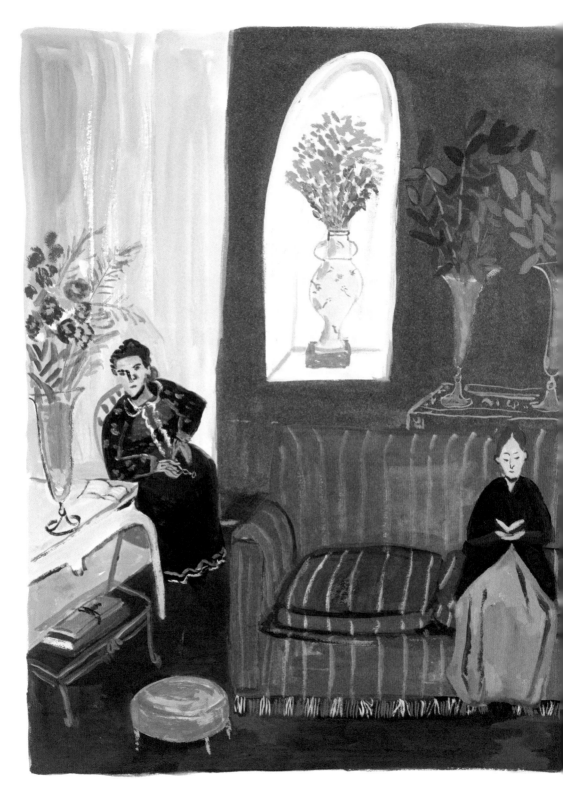

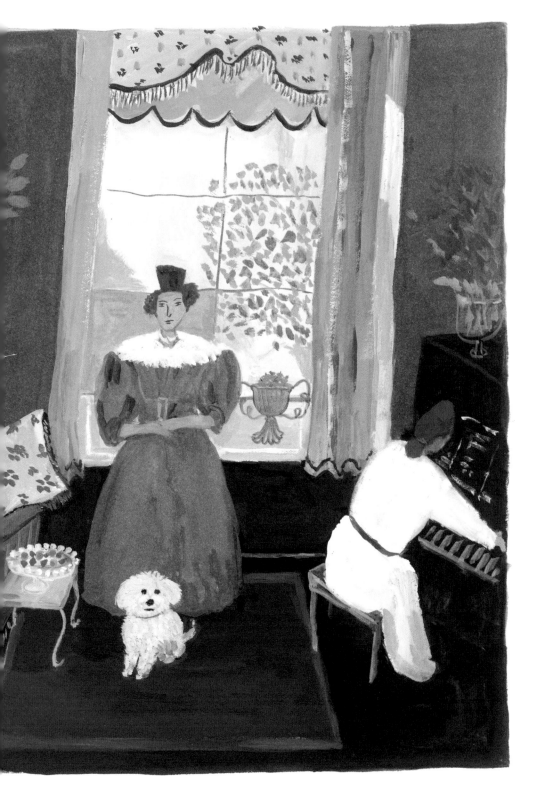

INADVERTENCES
(ONIONS AND OPINIONS)

Last night, at a dinner party,

I inadvertently insulted someone at the table.

And inadvertently, someone insulted me.

Inadvertently, I hurt someone's feelings.

And inadvertently, someone hurt my feelings.

A pileup of inadvertences.[*]

People are sitting around a table talking.

Round and round the sentences go.

As dizzying as a merry-go-round

spinning out of control.

More and more sentences.

More wine. More opinions.

And then, in the blink of an eye,

a random sentence stabs you in the chest.

[*] There *are* good dinner parties.

But who did I stab?

Who did I send home fuming and sulking?

Is it the end of the world to say something
hurtful or to be hurt? It is good to be with people.
Laughter. Bonhomie. Conviviality. Fortified
with goose, lingonberries, roasted potatoes and
caramelized onions. And to drink some schnapps.
Or claret. Or a generous portion of Hefeweizen?
And then for dessert, a large slice of cherry
strudel. Or perhaps a kugelhopf?

> Fortified with such a meal,
> we need not collapse with remorse over
> every little thing that is uttered.

> > Strong onions.
> > Strong opinions.

GREEN CHAIR

Once, I sat in this room
with this little dog.
Everything was beautiful.
Before we went into dinner,
out of the blue,
she said, quite clearly,

"Pace yourself."

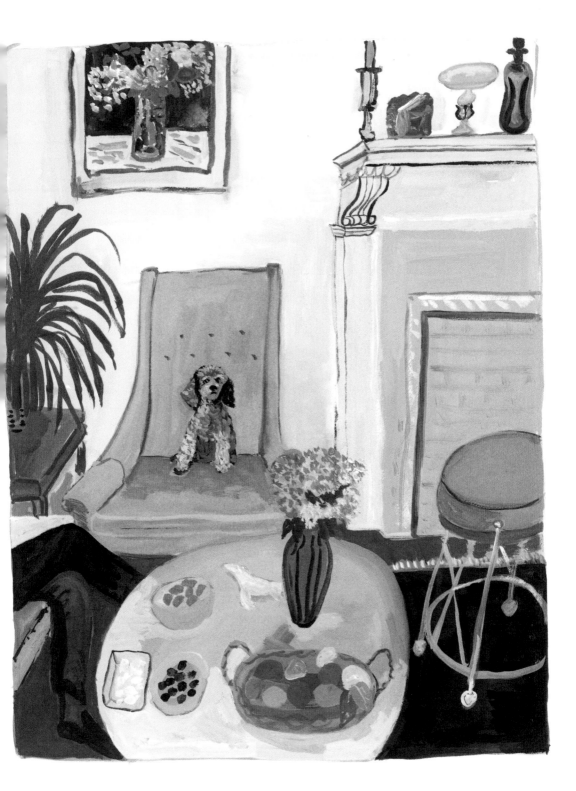

EVERYTHING

Everything is perfect.

Everything is good.

Everything is in its place.

Everything is mended.

 There is nothing left to mend.

Everything is washed. Folded. Ironed.

Put away in neat stacks.

There is lavender in the drawers

 and the drawers open easily.

Everything is done.

Everything is sorted out.

 Cleaned. Polished.

 Put away.

Everything is finished

 and there is nothing left to say.

There is nothing left to say or do

but sit quietly in the middle of the room

and look at the vase, flowers and books.

And yet.

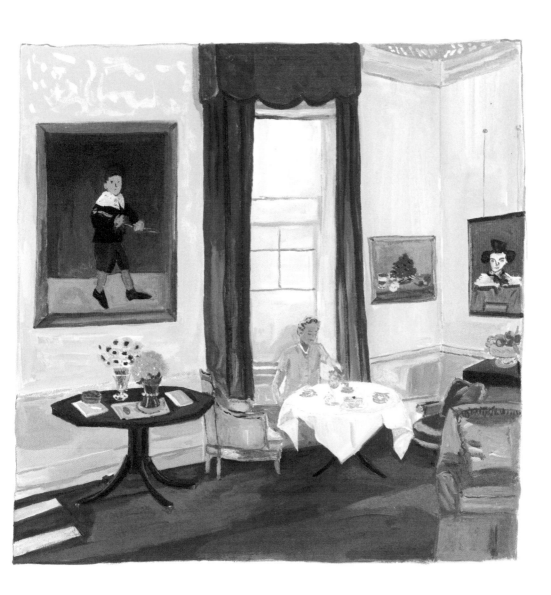

Everything is a mess.

Everyone is undone.

Everything is broken.

Everyone is sad.

Everyone is depressed.

Everything is hopeless.

Everyone is desperate.

Everyone is wrapped in malaise.

A dense blanket of malaise

covers everyone on earth.

And yet.

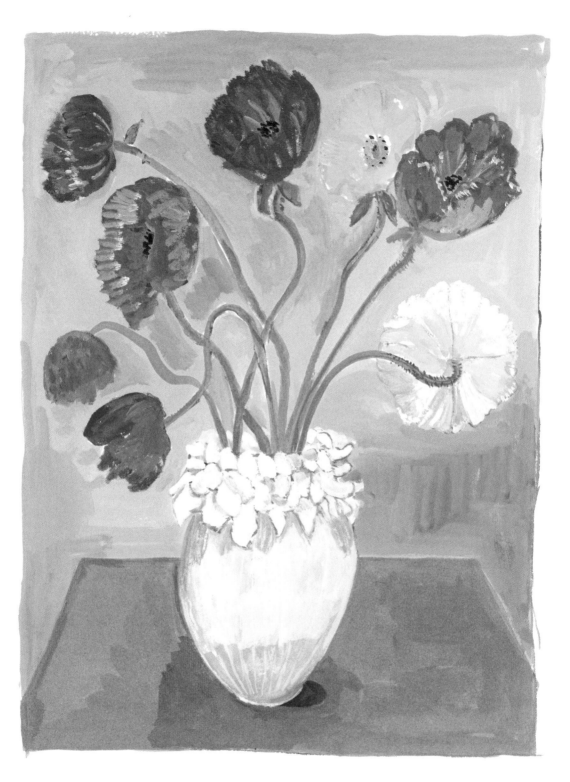

Everyone continues to live.

Everyone reconsiders despair.

Everyone starts to have a good time.

Everyone starts to enjoy life.

And yet.

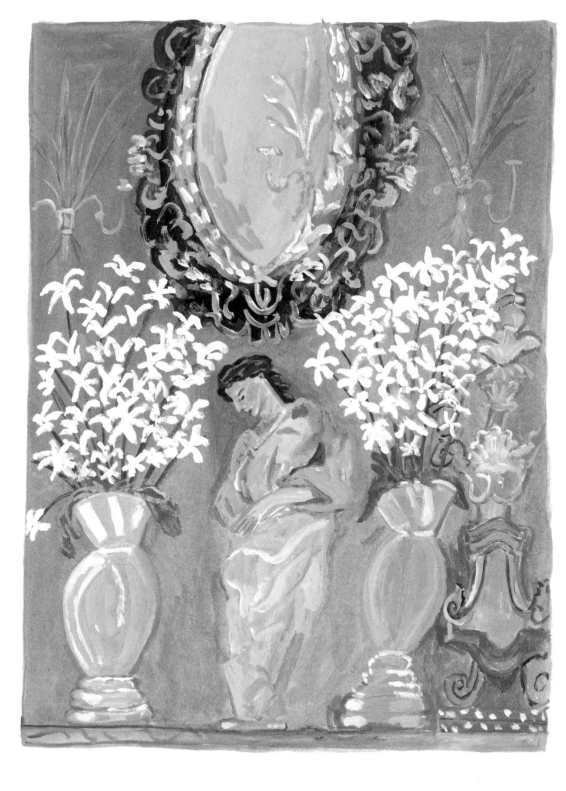

WAR, STILL

Wars surround us.
 And always will.

To understand why,
you would have to go back
to the beginning of time.
 And still you would be baffled.

You would cry out in anguish.
 But to no avail.
You could shake your fist at the heavens,
or fall to your knees in weeping prayer.

 But still. To no avail.
 Such is the world.

S. B. AND S. B.

My mother Sara Berman and the actress Sarah Bernhardt
drove men wild. In the seaside cafés of Tel Aviv, where
tango music played and awnings fluttered, men would
throw themselves at my mother. She would have none
of it. Though I think she must have enjoyed the attention.

Sarah Bernhardt was, of course, adored to distraction
by the whole world. She had lovers galore. Overlapping.
Intersecting. Unending affairs. The Prince of Wales being
one. My mother was also in love with someone British.
But that did not work out. Bernhardt had a pet alligator.
She napped in a coffin. A perfect still life.

> Bernhardt was buried in Père Lachaise.
> Tens of thousands thronged after the funeral cortège.
> The hearses were blanketed with massive waterfalls
> of white flowers, cascading wildly to the ground.

My mother was buried in a cemetery outside Tel Aviv.
We scraggled after her as her body was wheeled on an old
wooden plank, no flowers at all. She was placed in the
ground as far away as possible from my father, wrapped
only in a white shroud as is our ancient custom.

Sarah Bernhardt in bananas chapeau.

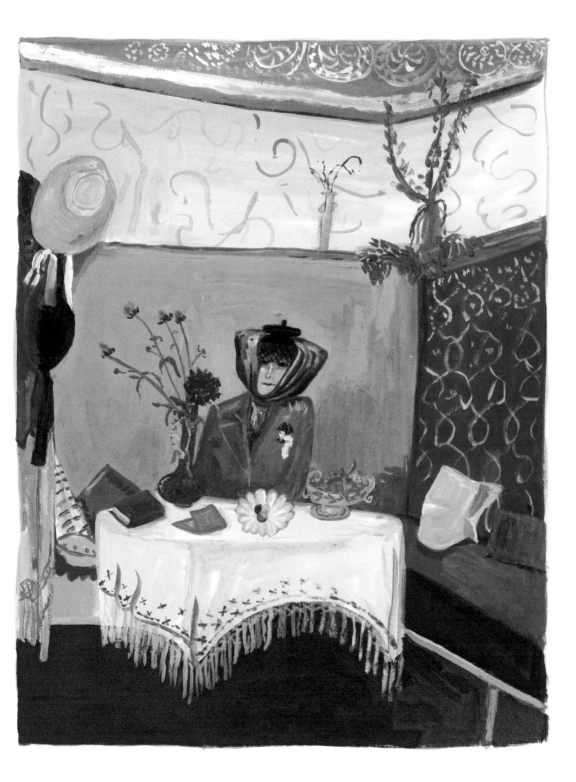

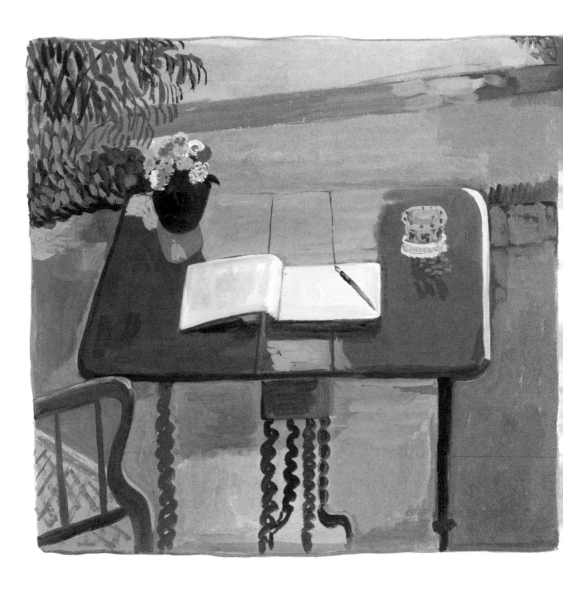

FANCY GOODS STORE

Perhaps in honor of the grandparents I never met
who perished in Belarus, I plan on opening a
general store. Carrying essentials of all kinds.
Like thread, notebooks, stationery and stamps.
Pencils and pens of all sorts. Things to help you be
a writer, like Virginia Woolf let's say.

> But also seemingly less essential items like balls
> and hats. Though balls and hats are clearly
> just as essential as anything.

All of the people that I love who are no longer alive
will help me out in the shop. They can help me
make decisions. I can say whatever I think
without hesitation. And they can do the same.

If they disagree with me I will not be insulted
or irritated as I would be in real life.
That is the way it is when you speak to dead people.

> There is much less rancor.

> Much more love.

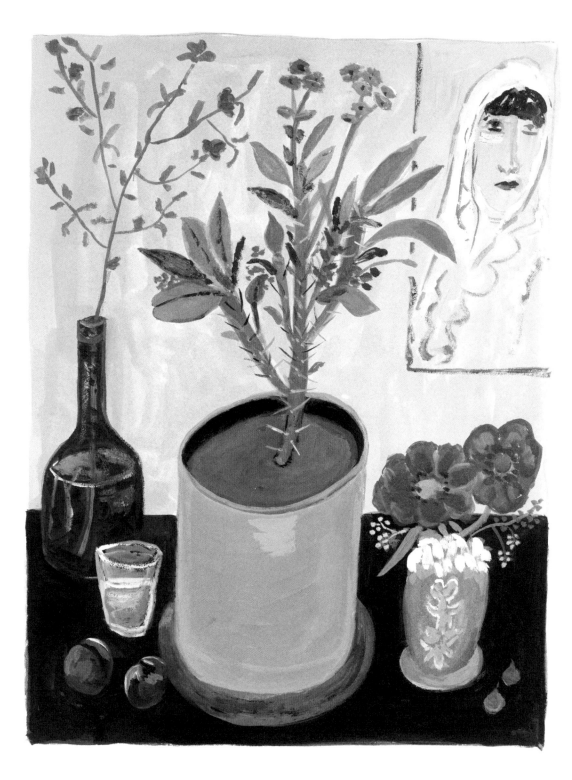

CHICKEN FAT

Our downstairs neighbor in the Bronx was pregnant and depressed. The thing that cheered her up was to have my mother sit with her at the kitchen table. Another thing that cheered her up were chicken fat sandwiches. Toasted rye bread smothered with rendered chicken fat and fried onions.

Schmaltz.

That made her happy.

For *a bit*.

In her later years my mother was not a big fan of friendships. She worried that if you made a friend you were bound to be disappointed and then what?
How do you get out of it?
Better not to make friends and not be disappointed.
She did have friends. And talked on the phone.
And called them darling.
But in her heart, there was a limit.

In the end there was just family.

Your family.

My family.

Your remorse.

My remorse.

All the same, right?

Vast skies full of remorse.

Oceans of remorse.

But enough.

There should be merriment.

And good cheer.

Good tidings. Well wishing.

Tables laden with food.

Children playing.

Gatherings of kinfolk.

Seeing the best.

Forgiving the worst.

If there is remorse,

let there be a limit to remorse.

A way to shake off the heavy weight.

How to do this?

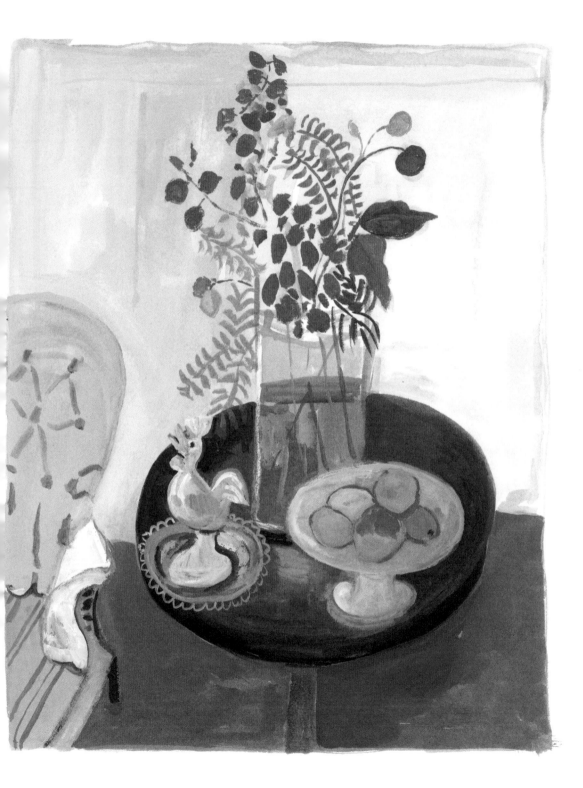

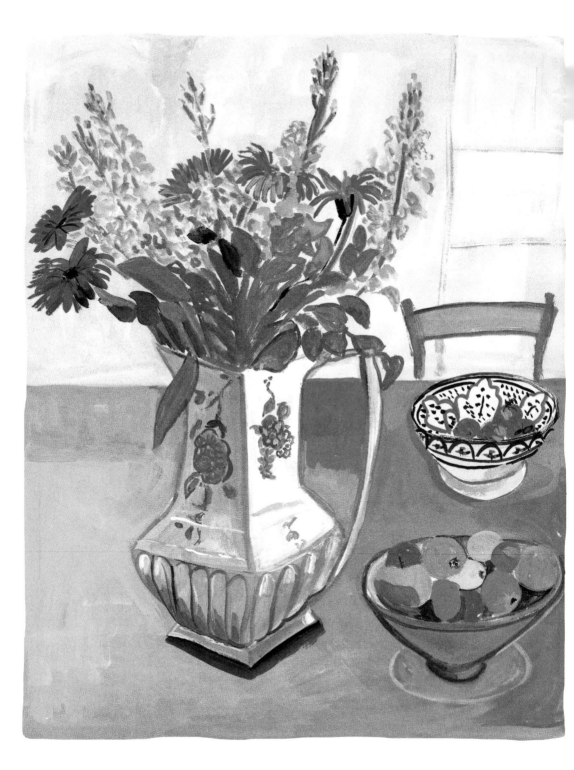

Perhaps, for now,

it is better not to talk.

Perhaps it is better just to sing.

To walk.

To look at trees.

To talk to dogs.

To inhale the scent of flowers.

To read books.

To listen to music.

To drink pots of tea.

And not talk,

just sing.

For Tibor

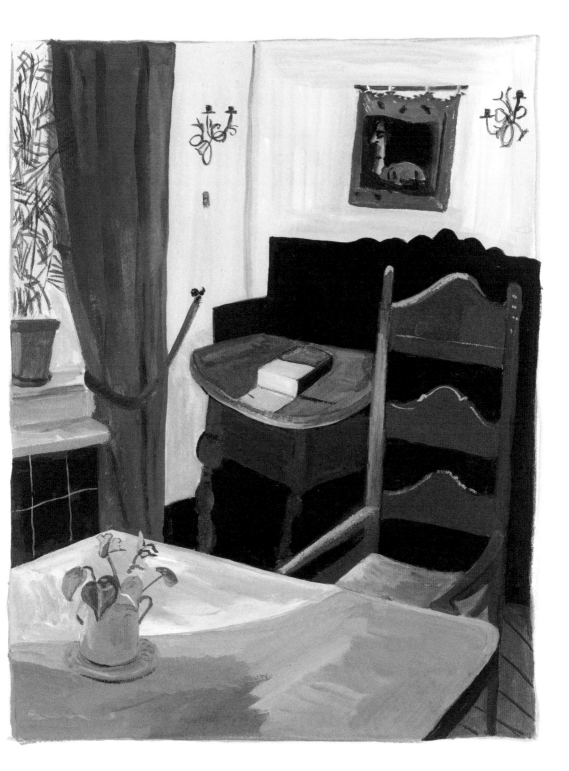

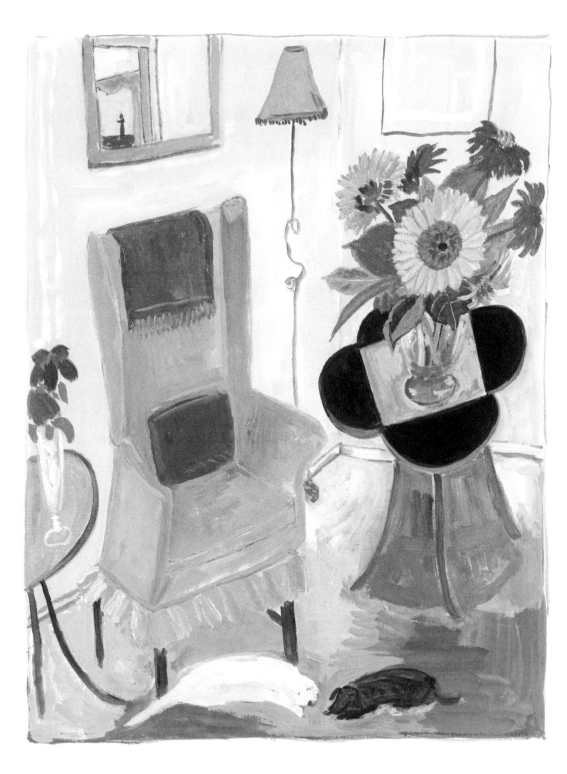

and Sara

paintings

index

TEXT AND ART

MAIRA KALMAN

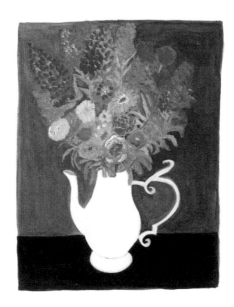

EDIT AND DESIGN

ALEX KALMAN

STILL LIFE WITH REMORSE. Copyright © 2024 by Maira Kalman.
All rights reserved. Printed in Canada. No part of this book may be used or
reproduced in any manner whatsoever without written permission except in the
case of brief quotations embodied in critical articles and reviews.
For information, address HarperCollins Publishers,
195 Broadway, New York, NY 10007.

HarperCollins books may be purchased for educational,
business, or sales promotional use. For information, please email the
Special Markets Department at SPsales@harpercollins.com.

Translation of *Lachen und Weinen* with kind permission of Richard Stokes.

FIRST EDITION

Library of Congress Cataloging-in-Publication Data has been applied for.

ISBN 978-0-06-339181-9

24 25 26 27 28 TC 10 9 8 7 6 5 4 3 2 1

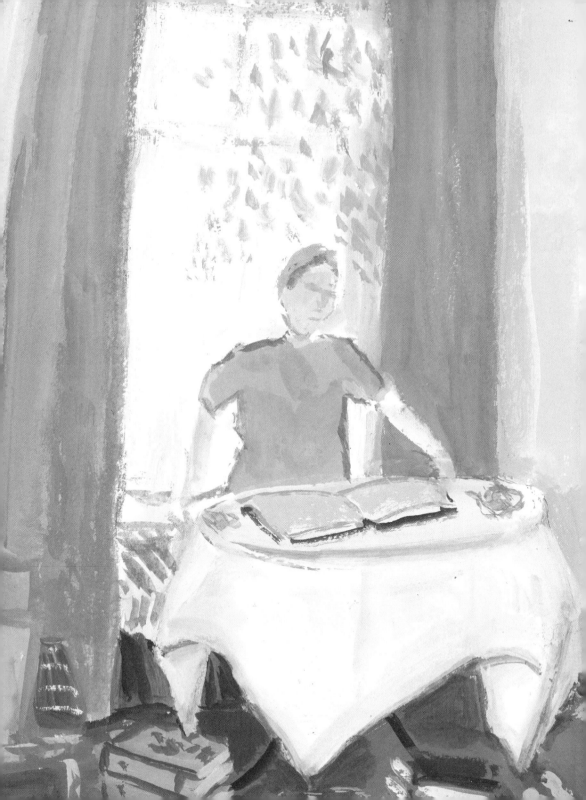